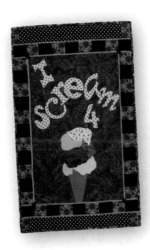

celebrate the
day with quilts

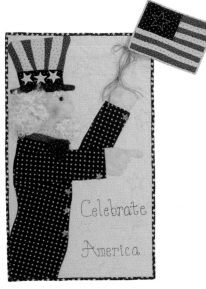

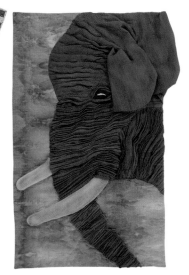

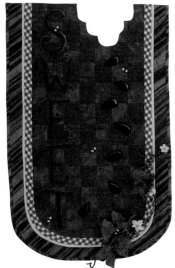

celebrate the day with quilts

An Art Quilt Challenge

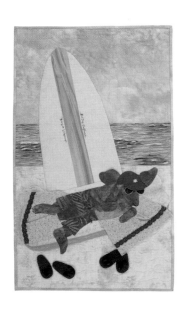

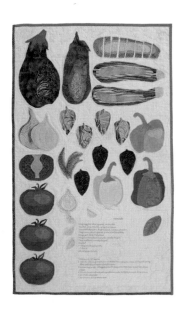

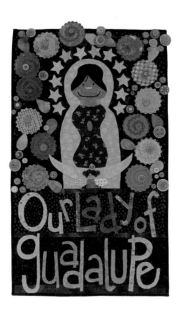

Shannon Gingrich Shirley

Schiffer Publishing Ltd

4880 Lower Valley Road • Atglen, PA 19310

Type set in Wendy & Merriweather Sans

ISBN: 978-0-7643-4613-2
Printed in China

Published by Schiffer Publishing, Ltd.
4880 Lower Valley Road
Atglen, PA 19310
Phone: (610) 593-1777; Fax: (610) 593-2002
E-mail: Info@schifferbooks.com

For our complete selection of fine books on this and related subjects, please visit our website at www. schifferbooks.com. You may also write for a free catalog.

This book may be purchased from the publisher. Please try your bookstore first.

We are always looking for people to write books on new and related subjects. If you have an idea for a book, please contact us at proposals@schifferbooks.com.

Schiffer Publishing's titles are available at special discounts for bulk purchases for sales promotions or premiums. Special editions, including personalized covers, corporate imprints, and excerpts can be created in large quantities for special needs. For more information, contact the publisher.

dedication

To my Mum, Jill Gingrich. None of this
would be possible without all of your help in
the background. Thank you for always being so
willing and supportive to lend a helping hand
to help me reach my goals. I love you!

acknowledgements

Thank you to the artists who gave of their
time and talents participating in this challenge.
The quilts you created are amazing and I appreciate
you allowing me to share your work with the world.

Thank you to Mary Kerr for helping me with
the photography; you are right, it is much easier
with two and the drive is more interesting as well.

Thank you to Beth Wiesner, Laurie Moody,
Marianne Gravely, and Kathie Buckley for helping
me with the editing and organizing of my manuscript.

Thank you to the staff at Schiffer Publishing, Ltd.
for the amazing books you make possible
by supporting the authors with our visions.

contents

introduction

We all have special days in our lives like birthdays and anniversaries, and many people celebrate the major holidays like Memorial Day, Fourth of July, and Thanksgiving. Still others celebrate lesser known days like Secretaries Day, Earth Day, or National Quilting Day. Thinking about these lesser known celebrations days me wonder what other special days there might be. Through an internet search, I discovered that there are hundreds. Some are international or national. Many are serious, but there are dozens of silly and seemingly random special days that are celebrated every year as well.

In March 2012, I challenged members of Cabin Branch Quilters, Stone House Quilters, the Quilt Professional Network, the Mason Dixon Quilt Professionals Network, and a few friends to find a day that inspired them and to design a quilt to celebrate that day. The rules were simple: make an 18 inch wide x 30 inch long quilted wallhanging using any quilting technique. What better way to celebrate and honor a special day than to make a quilt? We quilters are always looking for another reason to buy more fabric or use up some of our stash while enjoying one of our favorite things to do.

I understand that the idea of making a quilt to celebrate November 14, National Pickle Day may seem rather bizarre. But, what if your grandson's favorite food is pickles? Or your favorite deli is Katzinger's in Columbus, Ohio, where they have barrels of free pickles to eat with your sandwiches? Then the idea of celebrating National Pickle Day becomes a bit more personal. I think everyone can get more inspired when they feel that connection. Some artists chose a holiday that fell on their birthday, or a family member's birthday. Some chose a day to celebrate a special person in their lives, others celebrated a pet. A few chose to celebrate a special place and activity, while others chose their day based on a love of the subject, and quite a few chose to celebrate a memory.

Fifty-three artists accepted the challenge and they stitched a total of 72 amazing quilts. I have thoroughly enjoyed reading their stories and studying their quilts, and I trust you will as well. It is my hope that in reading their artist statements and seeing their finished quilts, you will be encouraged to try designing a quilt to celebrate a special day or event in your life.

So many of the quilters I meet say that they must have a pattern to make a quilt, but with practice, I believe that everyone can play with and develop their own ideas. Relax, enjoy the process, and know that everyone is unsure at one point or another when they are designing something new. Remember, you are the artist...if you like it, that is enough!

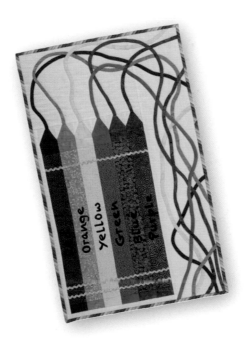

Let's take a look at special days of each month
and see which inspired the artists' quilts. Take note of how
the quilt began: was there a personal connection? What was the
design process: did the artist have to overcome any problems?
What techniques were used? The answers to these questions
will vary from quilt to quilt. Some might even spark ideas
for you to use when you design your next quilt.

I have included a list of holidays for each month.
These are, by no means, the only holidays, just the
beginning! I have highlighted the days that were
chosen by artists who participated in this challenge.

Each time you look at this book I believe you will be
caught by the different details in the quilts and the variety of
techniques used to solve various design challenges. Enjoy these quilts
as you begin the celebration of a year's worth of special days!

sunday	monday	tuesday	wednesday	
			First Foot Day 1	
NATIONAL BIRD DAY 5	· Bean Day · Cuddle Up Day 6	Old Rock Day 7	· Bubble Bath Day · Male Watcher's Day 8	
· Feast of Fabulous Wild Men Day · National Pharmacist Day 12	· International Skeptics Day · Make Your Own Dreams Come True Day 13	**DRESS UP YOUR PET DAY** **BALD EAGLE DAY** 14	National Hat Day 15	
NATIONAL POPCORN DAY 19	· National Butter Crunch Day · Penguin Awareness Day 20	· National Hugging Day · Squirrel Appreciation Day 21	National Answer Your Cat's Question Day 22	
Spouse's Day 26	· Chocolate Cake Day · Punch the Clock Day 27	National Kazoo Day 28	National Puzzle Day 29	

thursday	friday	saturday
Run up the Flagpole and See if Anyone Salutes Day 2	· Festival of Sleep Day · Fruitcake Toss Day · Humiliation Day 3	Trivia Day **WORLD BRAILLE DAY** 4
Play God Day **BALLOON ASCENSION DAY** 9	· Houseplant Appreciation Day · Peculiar People Day 10	Step in a Puddle and Splash Your Friends Day 11
National Nothing Day 16	Ditch New Years Resolutions Day 17	· Thesaurus Day · Winnie the Pooh Day 18
· National Pie Day · National Handwriting Day · Measure Your Feet Day 23	· Beer Can Appreciation Day · Compliment Day 24	Opposite Day
National Inane Answering Message Day 30	· Backward Day · Inspire Your Heart with Art Day 31	

World Braille Day

by Shannon Shirley

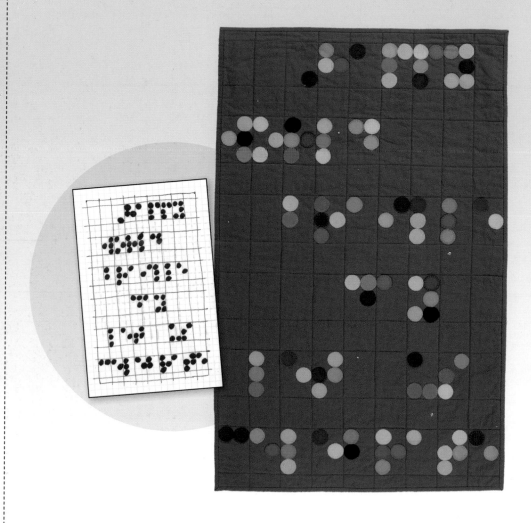

january 4th

This day is to honor and celebrate the opportunities that the braille system has made possible for the blind and visually impaired communities. The braille code was created in 1821 by the Frenchman Louis Braille when he was just fifteen years old. January 4 was chosen as it was his birthday.

When I was reading the various holiday lists and came across World Braille day I started thinking about all the dots that make up the alphabet. I love dots and I thought it had interesting possibilities. I decided to use all solid fabrics, creating a more modern look than I usually make.

First I got out graph paper and marked a rectangle 18 squares wide and 30 squares tall because the finished size of the quilt is 18" wide by 30" long. I knew that each letter of the alphabet was based on cells of six dots, 2 wide 3 tall, so I thought about

different arrangements of letters and row. If each dot was one inch, then letters 2 dots wide divided evenly into 18 inches. This meant that each row could have up to 9 letters or spaces. I then thought about various arrangements of the rows which were 3 dots tall. I ended up choosing 6 rows of three dots each with one inch at the top and bottom and two inches between the rows. I searched online for a braille translator and played with a variety of sayings and chose, "Happy world braille day; let us celebrate."

I marked the grid on the fabric with a Fons and Porter White pencil that stayed on the fabric until steam was used to remove them. I traced a quarter onto Heat n Bond Lite® 98 times, because I would need that many dots to create my saying. I used 49 different solid fabrics to make

my dots, two of each color. I fused the dots in place on a solid gray background and went on to hand blanket stitch each circle in place using 2 strands of embroidery floss that matched each dot. This added to the tactile nature of the quilt, because it raises the edge of each dot. I quilted the original lines that I had drawn on the fabric using a walking foot. This defined the cells of six spaces that braille is based on.

I finished this quilt, *"Let Us Celebrate,"* with circular labels forming a braille letter, and added outline stitching along the binding with pink embroidery floss to camouflage my not so invisible stitches. I like the way it looks, so I will have to remember this for other quilts, on the front or back.

Woodbridge, Virginia | www.onceinarabbitmoon.com

National Bird Day

by B.J. Titus

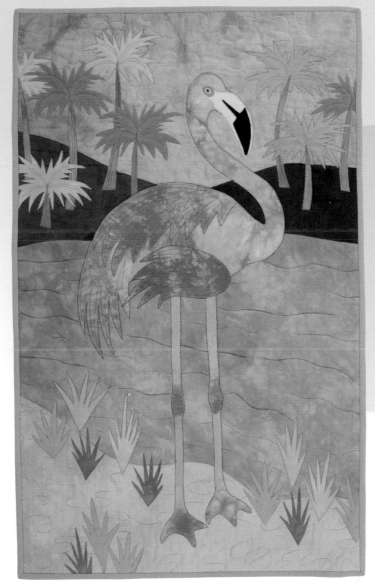

january 5th

The decision to select National Bird Day as my particular holiday was two-fold. First and foremost is my love of birds. I have been a bird watcher since childhood, and my copy of *A Child's Book of Birds* was a constant companion during summer months when birds were more plentiful. The second reason is that January is my birth month.

With a love of all things tropical, I tossed around various bird options: toucan, parrot, and macaw. While discussing the challenge with a coworker, she thought a bird with long legs would perhaps be more suitable for the particular size requirements. The first species that came to mind was the flamingo. Thus, the birth of *Flossie*.

Creating the focal point for my quilts is usually the easiest part of the design process. Filling in the background, however, is sometimes more of a challenge. I always research the subject of my quilt and try to remain true to the coloring when possible. Since Flossie resides in the tropics, I knew palm trees would be one element used on the surface of the quilt, and knowing that flamingoes feed in shallow, marshy areas would require reed-type foliage and water as other elements. I decided to add some mountains in the distance for interest.

This original design was created using artist-dyed fabrics, fused appliqué finished with edge stitching, and machine quilting.

Thorndale, Pennsylvania | www.bjtitus.com

13

Balloon Ascension Day
by Kathleen Davies

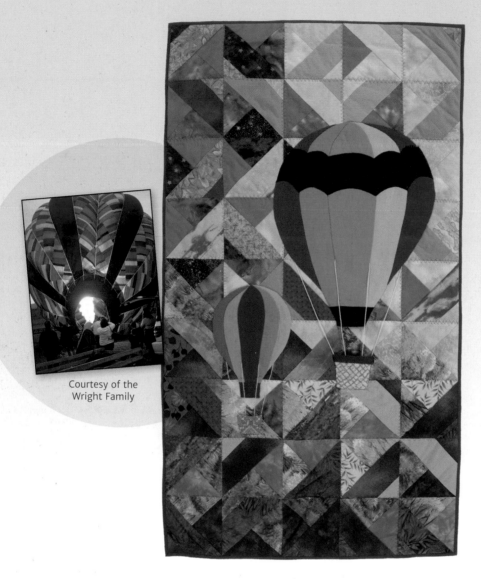

Courtesy of the
Wright Family

january 9th

On the morning of January 9, 1793, history was made in French skies, as Jean Pierre Blanchard made the first aerial trip in a yellow hot air balloon. Watching balloons ascend into the skies has become very popular, and there are many festivals around the country.

I have wanted to make a quilt using hot air balloons as design elements since a friend chose them as her theme for a West Milford Heritage Quilters box party project. The wild colors and sensuous shapes are appealing, as is their promise of adventure.

I was also taken by the possibilities of constructing part of the larger balloon in bas-relief. If I find the right dolls, there will eventually be "people" in the basket. My quilting is now tying into my early love of dollhouses and other miniatures.

The background is made from forty-five Chop Suey blocks, all different, oriented to give the effect of a landscape, from sunlit skies above, to trees and other vegetation below. The balloons themselves are composites of free clip art, photographs, advertisements and imagination.

I have loved the "challenge" aspect of this quilt. I've gone from near paralysis at having to make a piece that fits a theme, a color or a size dictated by the challenge, to enjoying the process. I think this represents a new direction for my future quilting.

My quilt, "*Hot Air Balloons,*" is made using machine piecing and hand appliqué, and is quilted by machine using a decorative stitch.

Hillburn, New York | www.kdotquilting.com

Dress up Your Pet Day

by Ginny Rippe

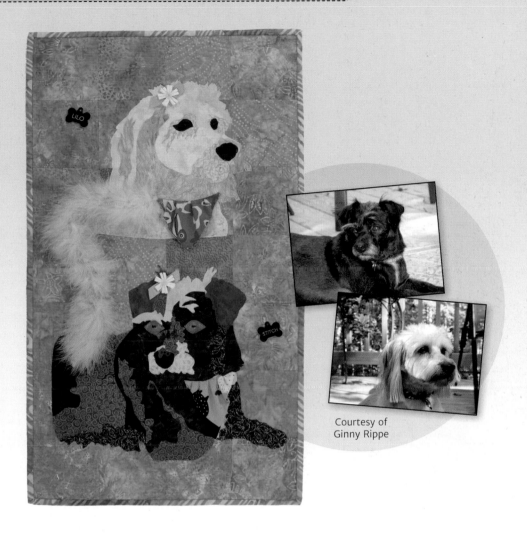

Courtesy of
Ginny Rippe

january 14th

For Shannon Shirley's Celebrate the Day Challenge, I chose "National Dress up Your Pet Day," January 14, to honor our beloved rescue dogs, Lilo and Stitch, who are the models for this quilt. It seems like a perfect opportunity to showcase their fancy scarves and fashion accessories.

Lilo and Stitch, terrier mixes, were rescued from a rural shelter in southern Virginia by the Homeward Trails Animal Rescue and transferred to a foster home in Maryland when we found them in 2007. We promised them a good home with lots of love and assurances that no one would ever mistreat them again. They were a little shy and fragile at first but soon became outgoing and happy members of our family.

Lilo and Stitch enjoy dressing up in their collection of jackets that my friend Kathy and I made for them, Ninja Turtle and Mickey Mouse fleece jackets, and Amy Butler designer rain coats. Their outfits are accessorized with brightly lit, colorful leashes. They are the best dressed dogs in the neighborhood during the winter months!

I used the photos above as my inspiration. The process to create the quilt began by using a Tracer projector to enlarge the photos on paper. It was a trial and error process to get the pictures to just the right size with accurate details. The pictures were then transferred to fusible backing and the auditioning of fabrics began. Many fabrics were used to recreate their portraits and once decided upon, they were fused to muslin, and then fused to the background. Stitch's photo had a shimmer of blue in it so I took "artistic license" and used a variety of blue fabrics to complete her picture for a different look. The light brown, gold and tan fabrics used for Lilo's picture enhance her curly and frizzy "blonde" look. I used a variety of orange batik fabrics in the background to add interest and to show case their light and black fur. My goal was to show their personalities through fabric — Lilo is ever alert and ready to track a deer, and Stitch is the loyal guard dog.

The quilt was machine quilted on a Janome 6600. If you look closely, you will see their names machine quilted in the background. I added dog tags with their names to quickly identify who is who. Crystals were added for a little sparkle in their eyes and Stitch even has red crystals on her toenails as a touch of girly nail polish. I dressed them up with scarves, bows, flowers and a feather boa.

I enjoyed expanding my horizons for this challenge quilt and looking at it just makes me happy. My quilt, "*Lilo and Stitch*," is a reflection of the warmth and love they bring to our family.

Manassas, Virginia

Bald Eagle Day

by Cindy Sisler Simms

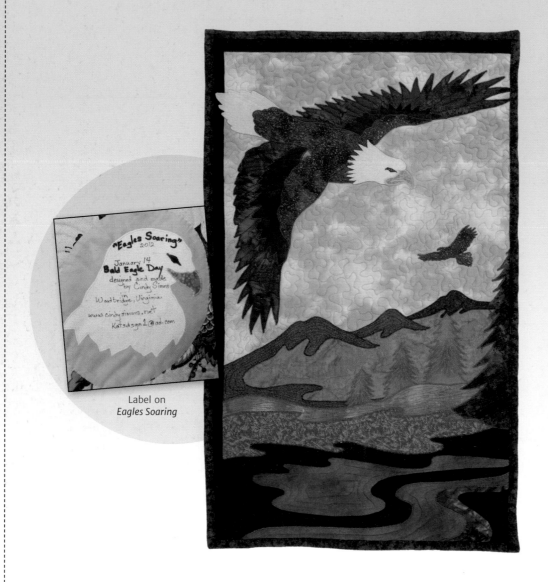

Label on
Eagles Soaring

january 14th

When Shannon asked for quilters who would like to create a quilt for her Celebrate the Day book and that we could pick which holiday we would do, I had to think before I volunteered to do a quilt.

I knew I wanted to do a holiday in January, which is my birth month and if possible to find any day and idea connected to the Native Americans, because part of both my husband's and my heritage is Native American. I wanted something that would also work as a symbol of our country. So after checking the links that Shannon provided and I didn't pick anything, I went to the internet and did another search for holidays. I found that several listed the bald eagle as a day and month, and both just happened to be in January. The bald eagle is connected to the Native American heritage and is also a symbol of this country. So I had found my holiday!

Now I had to draft my design and pattern, and I knew that I wanted at least one eagle soaring in the sky, if not both eagles. It took a couple of weeks for me to get the eagles proportioned right in the flying shape. Once I had the eagles drawn, then the landscape was the easy part. I also knew I was going to fuse my piece, so I started breaking down the pieces and drawing them on my fusible paper. Then I just had to start pulling the fabrics I needed. I found I had plenty of greens to choose from for the landscape, but found that I did not have the browns I needed for the eagles. The most time I think was spent on cutting out the pieces after the fusible was on the fabric, because I did not want to make a mistake and have to redo a piece. Once I had all the fusible on the fabric and the pieces cut out, the top went together in no time. I then layered my backing, batting and top and free motion quilted the piece. A narrow green binding finished the edge and the final touch was designing my label, which is an eagle head.

Woodbridge, Virginia | www.cindysimms.com

National Popcorn Day

by Kathy M. McLaren

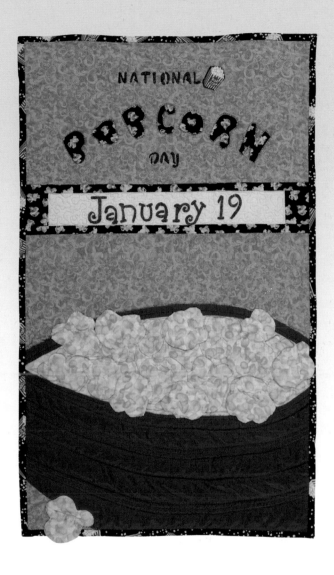

january 19th

I grew up with the opportunity to sew clothing, make quilts and generally play with fabric. My grandmother let me trace and cut templates at a very young age. Ripping fabric strips for log cabin quilts is another fond memory. Needless to say, I grew up and witnessed tremendous change in the way quilts were made, from making do with left over fabric from clothing projects to actually buying fabric to make a quilt. Now I make wall quilts just because I am inspired to try a new technique or express a feeling. It's not all about function.

My choice of quilts to "Celebrate the Day" was made simply by picking holidays that fell on family birthdays. Some dates were easier to choose the theme simply because it resonated with the family. Having the opportunity to create a quilt specifically for a birthday makes the day even more special. What a wonderful way to celebrate the day!

My daughter's birthday coincides with "National Popcorn Day" on January 19. This food is a family favorite to snack on during movies. I hoped to create a larger than life fabric bowl of popcorn. The only thing missing is the aroma of freshly popped popcorn. There actually is fabric with popcorn on it, but the scale wasn't appropriate for the quilt. I created my bowl of popcorn by finding a mottled fabric, which made me think "popcorn." My first attempt at the popcorn bowl consisted of multiple yellowish-white fabrics made into popcorn appliqués. This just didn't work visually. I opted to un-quilt, remove the appliqué pieces and create the popcorn from one fabric with trapunto and stuffed appliqué. Keep It Simple Sweetie ("KISS") became my mantra. The backing fabric and binding have the movie theatre popcorn box image – a great find for this quilt. The lettering for the quilt is a combination of stenciled Tsukineko Ink and appliqué.

Manassas, Virginia

sunday	monday	tuesday	wednesday
Purification Day 2	The Day the Music Died 3	· Create a Vacuum Day · Thank a Mail carrier Day 4	National Weatherman's Day 5
Toothache Day 9	**UMBRELLA DAY** 10	· Don't Cry Over Spilt Milk Day · Make a Friend Day · White T-shirt Day 11	· Abraham Lincoln's Birthday · Plum Pudding Day 12
Do a Grouch a Favor Day 16	· Random Acts of Kindness Day · Champion Crab Races Day 17	National Battery Day 18	National Chocolate Mint Day 19
· International Dog Biscuit Appreciation Day · Tennis Day 23	National Tortilla Chip Day 24	Pistol Patent Day 25	Tell a Fairy Tale Day 26

thursday	friday	saturday
		Serpent Day **1**
Lame Duck Day **6**	• Wave All Your Fingers at Your Neighbor Day • Send a Card to a Friend Day • Charles Dickens Day **7**	Boy Scout Day **KITE FLYING DAY** **8**
• Clean Out Your Computer Day • Get a Different Name Day **13**	• Ferris Wheel Day • National Organ Donor Day • National Heart to Heart Day **14**	Singles Awareness Day **NATIONAL GUMDROP DAY** **15**
• Cherry Pie Day • Hoodie Hoo Day • Love Your Pet Day **20**	Card Reading Day **21**	• George Washington's Birthday • Be Humble Day • International World Thinking Day **WALKING THE DOG DAY** **22**
International Polar Bear Day **27**	• Floral Design Day • Public Sleeping Day **NATIONAL TOOTH FAIRY DAY** **28**	**LEAP DAY (EVERY FOUR YEARS)** **29**

february

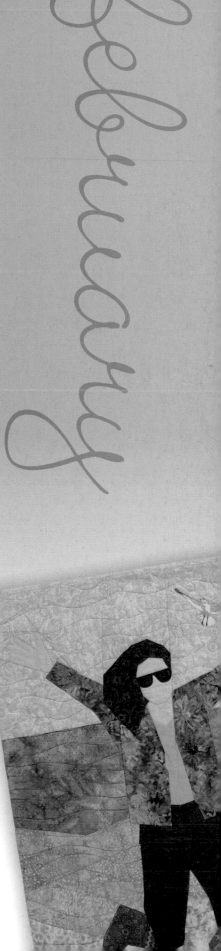

Kite Flying Day

by Barbara L. Scharf

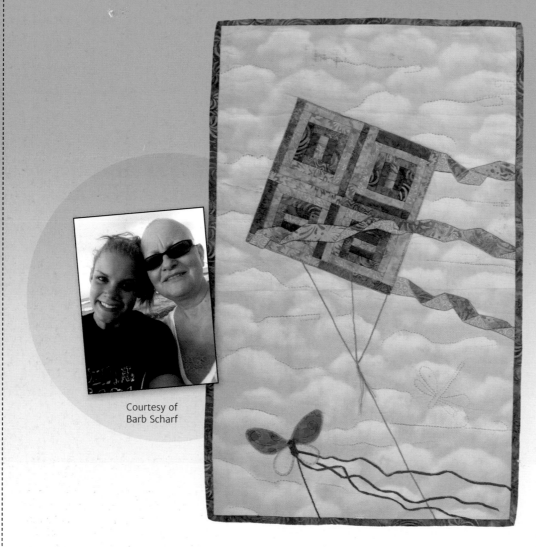

Courtesy of
Barb Scharf

february 8th

There are many kite holidays and festivals listed online, but February 8 is Kite Flying Day. The only one way to celebrate this day is to go fly a kite!

When I was a kid in Boise, Idaho one of the things I liked trying to do, especially in March, was flying a kite. Why I associated this activity with March, I don't remember. The kites in those days, at least mine, were of the triangular shape I tried to capture in this quilt. Of course they weren't nearly as colorful and probably made of paper and, I know, thin wood of some sort. I don't remember my brother and I ever getting a kite up...probably because they never lasted long enough. It was fun trying though.

In the late 1990s, my husband, a career navy man, was transferred to the Washington, D.C. area, and we moved to northern Virginia. We started taking our family to the Outer Banks of North Carolina, Kitty Hawk specifically, for summer vacations.

It's usually always quite windy in Kitty Hawk which is why, I'm quite sure, the Wright Brothers chose the location for their first flight. Every summer there are colorful kites of every shape and size flying for hours at a time. I love the sand, the sound of the ocean, and watching the pelicans and other sea birds flapping along with the kites in the wind.

My youngest daughter and a friend lived and worked in Kitty Hawk this past summer which afforded me the opportunity to spend most of my summer there as well. Throughout the season dragonflies and yellow butterflies joined the kites in the sky.

The log cabin blocks were a happy accident from another quilt in batiks in my favorite colors. These blocks and the butterfly were machine appliquéd. The clouds and dragonfly were originally machine quilted but the hand-quilting, though not perfect, I felt, was more attractive and "effective." The fabric for the backing and binding remind me of a hurricane swirling around. "Superstorm Sandy" wreaked havoc on Kitty Hawk in November 2012. "Our" cottage across the beach road most likely flooded and Hurricane Mo's, my daughter's summer employment and my favorite eatery, had to be gutted. Mo is working to be ready for next season.

Woodbridge, Virginia

Umbrella Day

by Jane W. Miller

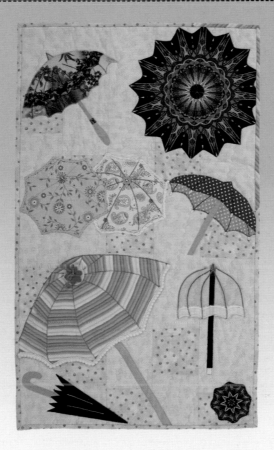

february 10th

So many people dislike rainy days, but I've always seemed to enjoy them. As a child, I would love to walk in the rain, listening as the drops fell on my umbrella. When my son was small, he'd make a tent out of his Dad's golf umbrella and enjoy sitting on the deck, listening to the drops, much like I had when I was his age.

If you look up "Umbrella Day" in the internet, you might find it is celebrated annually on February 10. This surprised me since I would have thought Umbrella Day would occur in April, given the expression "April showers bring May flowers!" Some sites encourage everyone to celebrate Umbrella Day by taking a walk, rain or shine, and being thankful the umbrella was invented.

As I began this project, I imagined a "sea of umbrellas," like a bird's eye view of a busy city street on a rainy day. I had difficulty transferring my mental image to paper when trying to create a plan. I began thinking of other people and wondering about their perceptions of rainy days. What would their ideal umbrella look like? What if my quilting friends could select their favorite fabric to have an umbrella made for them? These thoughts lead me to asking several of my quilting friends for a piece of fabric which would represent their ideal umbrella. My request resulted in a wide assortment of fabrics, and ideas kept "raining" down. One fabric looked more like a parasol. Could that be included in an umbrella quilt? Two of the fabrics blended beautifully, so I thought about incorporating them together into one umbrella. Another fabric suggested a beach umbrella. There have been many occasions where I have stayed on the beach in the rain, glad that my large umbrella sheltered me from the rain and wind. I searched the internet for images of other umbrellas to collect additional ideas for my Celebrate the Day Challenge. I used a fusible interfacing on the back of a few pieces and started arranging them on my design wall

My stash of fabrics has grown quite out of control. I have a shelf of various blues, with my taste leaning toward mellow, "tea dyed" colors, but none of my blues inspired me. I happened upon some fabric I was saving for a baby quilt, and the blue drops on the lighter blue fabric roused some enthusiasm. What if I took that playful blue fabric and arranged the umbrellas to cascade out of the sky, as if it were "*Raining Umbrellas*"? I continued cutting out umbrellas, including a plastic umbrella to represent the "bubble umbrellas" popular during my childhood. And I had to include a classic men's black umbrella, folded up after a long rainy day. Another friend provided a perfect fabric of an open umbrella which had to be included in this collage. Now, just looking at this quilt makes me smile as I remember the bits of fabric representing so many quilting friends seem to beam back at me, brightening any gloomy, rainy day.

It wasn't until after completing this challenge that I stumbled upon an old e-mail Shannon had sent me. She had listed many "umbrella" ideas, including miniature parasols found in adult beverages and enormous picnic table umbrellas. Regrettably, I didn't incorporate either of suggestions, but perhaps someone will be inspired to make their own quilt to "Celebrate the Day"!

Montclair, Virginia

National Gumdrop Day
by Pamela Baringer Shanley

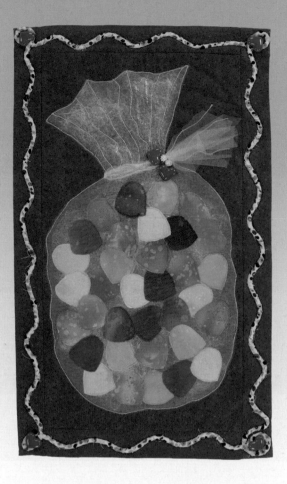

february 15th

No one knows who truly invented gumdrops, but they are considered to be at least 200 years young. They are made with fruit or spice-flavored pectin/gelatin and are typically covered in sugar. Today, similar gumdrop candies, Dots and Gummi Bears, are very popular. Celebrated the day after the very chocolate Valentine's Day, Gumdrop Day is just one of the dozens of happy, candy holidays. Celebrate today by making your own gumdrop candy!

When I was looking at the list of fun holidays, I immediately wanted to do Gumdrop Day. I have wonderful childhood memories of my grandmother's candy dish filled with spice drops. My father loved gumdrops but would only eat them after they got a little bit stale! My family uses gumdrops every year to make our Christmas gingerbread house. They are always the roof decoration on the house.

For the quilt, I saw the colors of those wonderful candies in my mind and I got excited. Of course I thought about Candyland's gumdrop mountains, gingerbread houses and candy wreaths! However, this holiday is February 15 and I did not think a Christmas theme was appropriate! I went on the internet to view wonderful, colorful photos of gumdrops. I did not buy a bag of candy, because I just started Weight Watchers!

The first design incorporated a young girl under an umbrella as gumdrops fell from the sky. But that image was everywhere on the web! I did not feel comfortable about copying that idea. I then thought about Candyland's gumdrop mountains, since I live near mountains. When I began sketching out the design and the typical shape of the gumdrop, I could not come up with anything fun. I became very discouraged and put away all the fabric and designs I had been auditioning.

After a few days, I began to think about what I liked about gumdrops and the idea finally came to me. Why not just show a beautiful bag of colorful gumdrops just ready to be eaten! Yum! I also wanted to use what I had in my own stash to challenge myself. I found the rainbow batik charm pack while organizing my stash and decided that this design was it! I had just purchased the red for the background and the dots for the backing at a recent Quilt Rally, because I love red and dots! I also love to accessorize. I used netting to encase the gumdrops in the bag and added buttons. I used Angelina fiber to make the bag sparkle and the silver thread around the bag is heat-set ribbon. I added fabric wrapped rope to the border.

I hope you enjoy the bag of gumdrops! No calories!

Radford, Virginia

Walking the Dog Day

by Stevii Graves

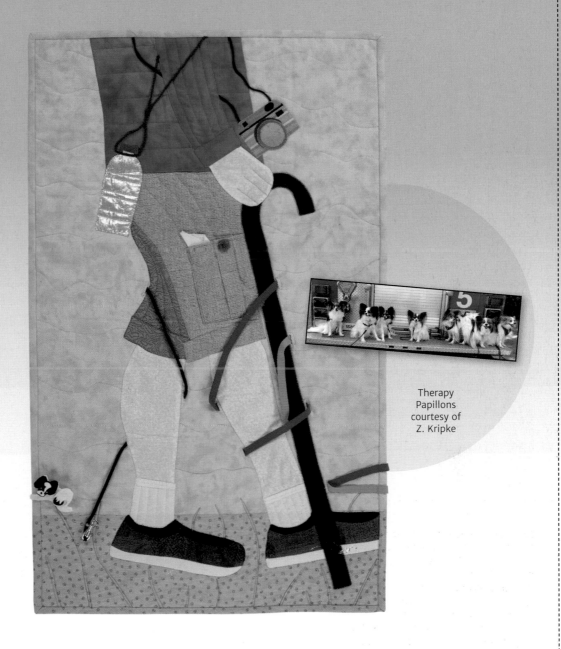

Therapy
Papillons
courtesy of
Z. Kripke

february 22nd

When the San Diego Papillon Picnic Club walks in Balboa Park, the sight of 20–30 adorable little butterfly eared dogs, all in a group, attracts a lot of attention. Members of the Club were always amazed watching our friend John Kennedy maneuver with three dogs, a cane and a variety of stuff hanging around his neck. John usually had at least one dog leash wrapped around his legs and cane. Occasionally one of the dogs would slip out of a leash and take itself on its own walk. This quilt honors John and all members of the Papillon Picnic Club of San Diego...two and four legged.

The quilt, "*John on a Dog Walk*," was constructed with a combination of raw edge and finished edge machine appliqué. The leashes were ones used by my Papillon, Dani, and were attached by weaving them through buttonholes placed next to John's legs on the quilt top. The run away dog is a polymer clay creation by Z. Kripke of LaJolla, CA. Part of the joy of being a quilt maker is the ability to take memories from the heart and put them to cloth so they can be shared with others.

Leesburg, Virginia | www.steviigraves.com

National Tooth Fairy Day
by Bunnie Jordan

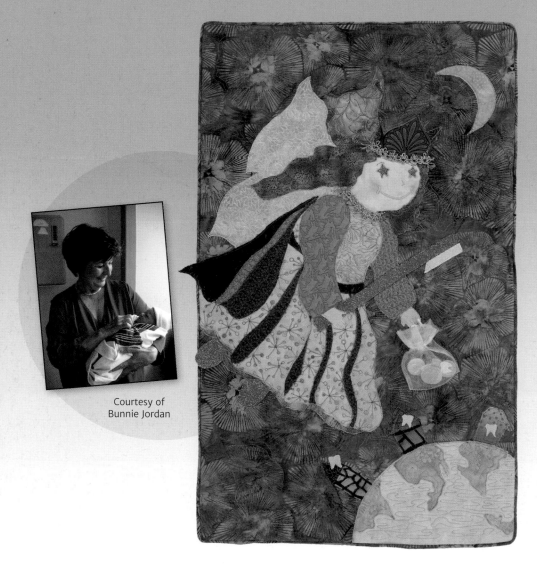

Courtesy of
Bunnie Jordan

february 28th

Losing a tooth can be frightening, but it's made a little less so when a child learns a fairy will come to visit and exchange the tooth for a present, usually money. The story of the tooth fairy goes back to the middle ages, and most cultures have their own version. Varying traditions may have the child throw the tooth on the roof, toward the sun, or bury it in the ground. Wherever you leave your tooth, even if it's lost, the tooth fairy knows and will find you to leave a gift.

In choosing a day to celebrate, I looked for something that could be fun. I'm a new Grandma, so I was also thinking of making something a little girl might enjoy. All children experience loosing their baby teeth, and the tooth fairy is a benevolent character who offers compensation to make the process a little easier. In fact, she is so popular, there are actually two Tooth Fairy Days, February 28, and August 22.

I took a whimsical approach in celebrating the tooth fairy. This fantasy figure is universal, so I depicted her flying over the world. In most traditions the fairy is usually a female who retrieves the tooth from under the child's pillow and leaves a reward. In some countries though, the fairy is a mouse, so I have a pocket in the shape of a mouse on the quilt back where a tooth can be placed. (Planning ahead for my infant granddaughter!)

No one really knows what the tooth fairy looks like, so I show her as I think a child might. I wanted her to appear playful, since this is a child's tale, and to look rather like a big kid herself. I used shades of purple and some fun bunny print fabrics for her clothing. This particular fairy also loves sparkle and not just on her crown; her shoes have to sparkle too. A glittering toothbrush seemed an appropriate wand. The quilt is fused, machine appliquéd, and machine quilted. I embellished with bits of trim and glitter foam and loose coins in the mesh bag. I hope she brings some sparkly smiles.

Vienna, Virginia | www.bunniejordan.com

Leap Day
by Shannon Shirley

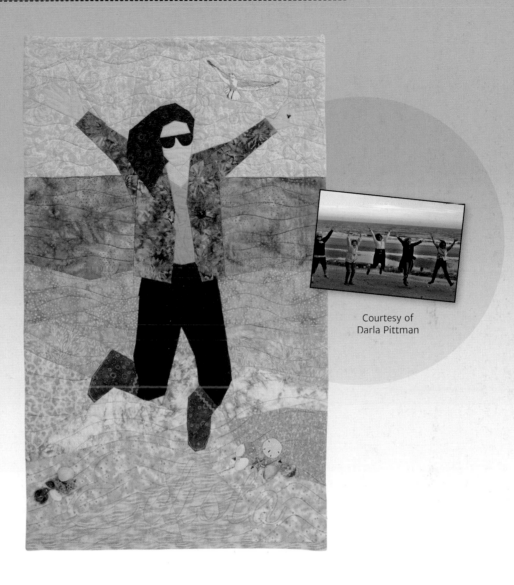

Courtesy of
Darla Pittman

february 29th

For February I considered Groundhog Day because we have a close friend whose birthday is on February 2, Love Your Pet Day because Rylie my dog is so cute; and National Margarita Day because I love frozen margaritas with salt (and it would fit well on the vertical challenge quilt); but I chose February 29, Leap Day.

February 29, 2012, I was very lucky to be at Edisto Beach in South Carolina with a group of friends. On leap day while we were out walking, we chose to take pictures of each other leaping. I decided that I wanted to celebrate the friendships and memories from this trip by making a quilt. I used parts from different photographs to make up my person. I have Mary's arms, one of Darla's legs and one of Cyndi's. Printed rubber boots and sunglasses were popular accessories, so I included those as well.

While we are there, we always feed the sea gulls and go hunting for treasures. Everyone finds sharks teeth, but I have yet to find one on my own. Most of the treasures are pieces I have found at Edisto, except for the sharks teeth, which Mary Kerr gave me from her collection. I used Gem-Tac™ Embellishing Glue to adhere them to the quilt.

I used Ruth McDowell's technique of creating a straight line drawing from my photograph and then created a freezer paper pattern to work from. The entire quilt is machine pieced except for the seagull and the sunglasses. It is free motion quilted using a variety of cotton threads and monofilament on my stationary machine. I quilted Edisto into the sand so that it does not distract your attention from the picture but still names the beach. Adding a facing instead of a binding allows the background to just keep on going.

Woodbridge, Virginia | www.onceinarabbitmoon.com

sunday	monday	tuesday	wednesday	
Old Stuff Day 2	• I Want You to be Happy Day • National Anthem Day • Peach Blossom Day 3	Hug a GI Day 4	**MULTIPLE PERSONALITY DAY** 5	
Panic Day 9	Middle Name Pride Day 10	Worship of Tools Day 11	Girl Scouts Day 12	
• Everything You Do is Right Day • Freedom of Information Day 16	• Submarine Day • Saint Patrick's Day 17	• Goddess of Fertility Day • Supreme Sacrifice Day 18	Poultry Day 19	
Near Miss Day 23	National Chocolate Covered Raisin Day 24	• Pecan Day • Waffle Day 25	Spinach Festival Day 26	
• National Doctor's Day • I am in Control Day • Take a Walk in the Park Day 30	National Clam on the Half Shell Day **NATIONAL CRAYON DAY** 31			

thursday	friday	saturday
		• National Pig Day • Peanut Butter Lovers' Day 1
• Dentist's Day • National Frozen Food Day 6	 7	• Be Nasty Day • International Working Women's Day 8
Ear Muff Day 13	**LEARN ABOUT BUTTERFLIES DAY** **NATIONAL PI DAY** 14	• Everything You Think is Wrong Day • Ides of March • Incredible Kid Day • Dumbstruck Day 15
• International Earth Day • Extraterrestrial Abductions Day • Proposal Day 20	Fragrance Day **WORLD DOWN SYNDROME DAY** 21	National Goof Off Day **WORLD WATER DAY** 22
 27	Something on a Stick Day 28	

march

Multiple Personalities Day
by Erin Underwood

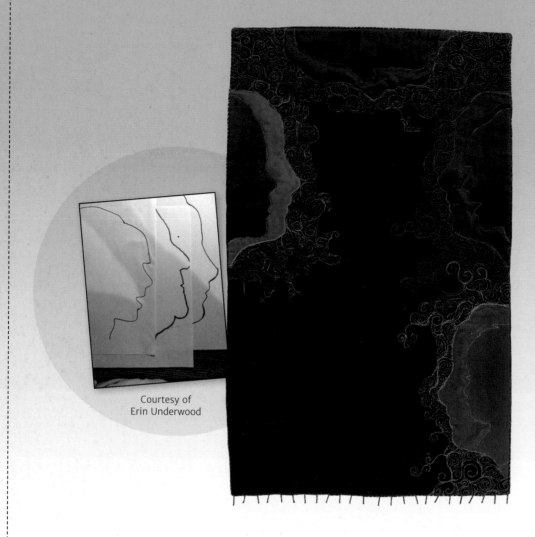

Courtesy of
Erin Underwood

march 5th

After spending an afternoon researching eventful days in the calendar, I settled on Multiple Personality Day, as it seemed to inspire me right away. Lots of ideas came to mind as to how to present this special day. I did a bit of research into the colors of emotion as well as symptoms, treatments, and outcomes of such a complicated condition. So then the next thing to do was to go shopping! With no real plan decided on, I searched out favorite stores that offered all sorts of beads and trims and specialty fabrics that may help my brain form a decision. And I just bought a collection of stuff. I auditioned the fabrics and felts and beads and trim, until I thought I found a color scheme that might work. To get a concept going. I played around with line drawings, until I could see something forming. This one happened to

be, "How many different personalities are there really inside our personality?" After putting some basic pieces together and sketching out a layout, I gleefully took my Work-In-Progress to my art critique group, Fiber Dimensions. I had nearly forgotten one of our members was a psychologist until she said I needed to do more — illustrate the healing process, offer hope, blend the personalities back together. It was rather funny how adamant she was that this should have a positive outcome even though it was only a quilt! I played around with her ideas as well as suggestions from the rest of the group, eliminated some silhouettes, created some new ones and changed the layout.

"Voices in My Head" was created using my variation of Shadow Trapunto. Felts, fusible web and shimmering fabrics were

used as well as cottons and batting. Extensive machine quilting with a variety of threads helps to add a bit of color to what could be considered a dark, dark quilt. A hand-beaded fringe was added on the edges to complete the quilt as well as get it up to the required size.

After all that extensive quilting and beading, I am not convinced that this quilt is healing. Perhaps it is even a bit more tormented than my psychologist friend would prefer. Hopefully it illustrates the struggles that we all go through to be who we are.

Elkton, Maryland | www.erinunderwood.com

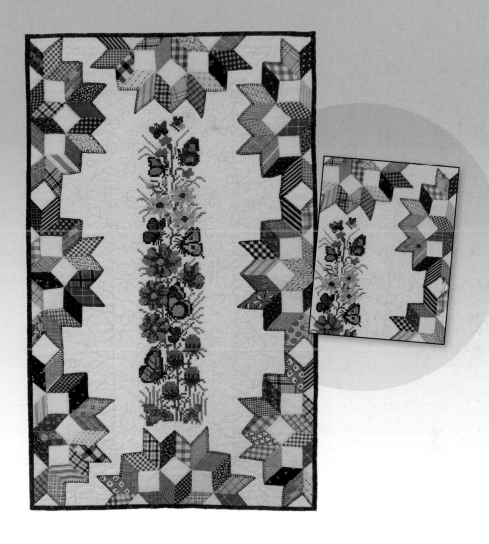

march 14th

While looking days at for March, I considered National Pig Day, because I know someone very special to me that loves and collects pigs; Old Stuff Day because I love spending time poking around flea markets and antique malls looking for old treasures; Poultry day was a possibility, because I've been wanting to make a chicken quilt like the ones Ruth McDowell makes. I also thought about doing a dandelion for Weed Appreciation day, but I ended up deciding to celebrate Learn About Butterflies Day.

While pondering ideas for this quilt, I thought about making a traditional quilt from colors that butterflies are attracted to. Another possibility was a quilt featuring host plants for the caterpillars. I also had a photograph of a butterfly sitting on a purple cone flower I had taken in my garden, that I could recreate in any number of techniques. Then I remembered I had a vintage cross stitch with butterflies on it. When I found it, I was pleased to see that it was long and thin, because that suited the shape of the challenge quilts.

I decided to combine it with four vintage star blocks that I had in my stash. I chose a background fabric in a color similar to the background of the cross stitch and bordered the embroidery to create a piece 19" wide x 31" long. Each star block was pressed flat and then cut in half. I arranged them around the edge of the quilt top and pinned them in place. I hand blanket stitched the stars in place using an indigo embroidery floss to define the edges of the stars. Using the cross stitch for inspiration I drew a design with a blue water soluble marker before free motion quilting to add texture to the background of this quilt.

I have always loved working with vintage textiles; they have a certain charm to them. I enjoyed working on this project and certainly learned a few things about butterflies that I didn't know.

Woodbridge, Virginia | www.onceinarabbitmoon.com

Pi Day
by Marianne H. Gravely

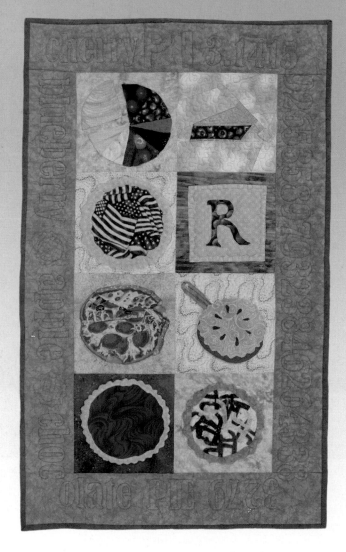

march 14th

I chose March 14 (Pi Day), because I have always liked the pun/joke of Pi/pie, and how math teachers and math lovers celebrate March 14 with pizzas and baked pies. I searched the internet for ideas for Pi Day but only found pictures of Pi and pizzas. My first few ideas revolved around combining baked pies with the math equations of Pi, but being neither math lover nor teacher, I couldn't get too far.

At a quilt retreat I discussed my tiny seed of an idea with Shannon. She urged me to make a quilt that would not just meet the "Celebrate the Day" Challenge requirements but would mean something to me. Well, that helped but since I am not a math lover, I was still stuck. Why did I pick Pi Day anyway? Then my friend Fran, a retired math teacher, mentioned a favorite Pi joke: "Pi R squared! Pi are not square, Pi are round!" This led me to think of different kinds of pies. There is the number Pi, and the pies we eat, and a favorite song, "American Pie." For Fran I stitched a square R pie, as well as a pie chart. My husband and father are both naval officers, and I grew up hearing the phrase "Red sky at night, sailor's delight," so for them I stitched a pun on the "sailor's delight"—a red *pie* at night. My original plan was to quilt Pi around the border, but then I decided to quilt the number Pi on one side and delicious pies on the other.

The biggest challenge for me in making this quilt (besides coming up with the ideas for the various pies) was that I had to design the blocks myself, with the exception of Ami Simm's "*Pie in the Sky*" paper pieced block. Searching for the best fabrics for the pie crusts and fillings was fun, but the challenge was sketching out the blocks and making them the right proportion so that they would fit within the size each pie block had to be. Luckily even the most artistically challenged quilter can trace a circle!

My quilt, "*For the Love of Pi/e*," is machine pieced, almost all of it is hand appliquéd, but there is a little fusible applique. It is machine quilted, some free motion and some with a walking foot.

Woodbridge, Virginia

World Down Syndrome Day

by Jane E. Hamilton

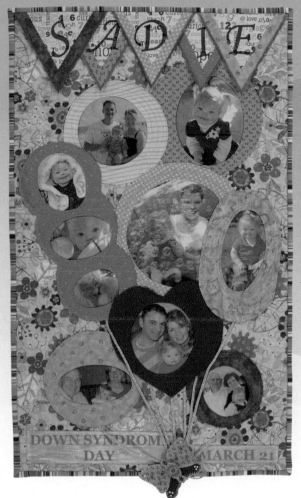

The Weikel Family, courtesy of Jane Haldeman Hamilton

march 21st

World Down Syndrome Day (or Trisomy 21) is celebrated March 21. Down Syndrome is the most common genetic disorder in humans. We do not know why this occurs, but we do know that each child with Down's syndrome is very special. As a culture we need to value the unconditional love given by these children, accept who they are as individuals, and include them in as many areas of our lives as possible.

This quilt piece is for my grand niece, Sadie Weikel, who was born with Down's. Sadie is a different kind of perfect, who brings tremendous meaning and joy to all who come in contact with her. Her parents, Kelley and Kevin, are her biggest cheerleaders, creatively encouraging her every accomplishment. With the additional close support of Great Gram, Grandparents Carole and Ray and Karen and Terry, family, and friends, Sadie's successes continue to abound. I chose a balloon bouquet to celebrate Sadie as the sky is the limit as to what she may achieve with the wonderful support of family and friends. Down's is just one part of her beautiful self!

The design process begins with research. Even though I did not include many words on the piece I needed to read more information on Down's. The pictures my niece sent conveyed what a joyous gift we have been blessed with. I immediately thought of balloons. I sketched the basic piece without much detail on notebook paper. Then, freezer paper was used to draft the quilt size and balloon shapes were free form cut and placed on the pattern piece to establish placement. The picture placement was marked on each fabric balloon and stitching was done to resemble a frame. After each balloon was made, I was able to move them on the background independently. Flags were made separately, and Sadie's name was added using Transfer Artist Paper. *"The Sky is The Limit"* is machine quilted and bound with a multi-colored striped fabric.

Kennett Square, Pennsylvania | www.janequilts.com

World Water Day

by Betty Jenkins

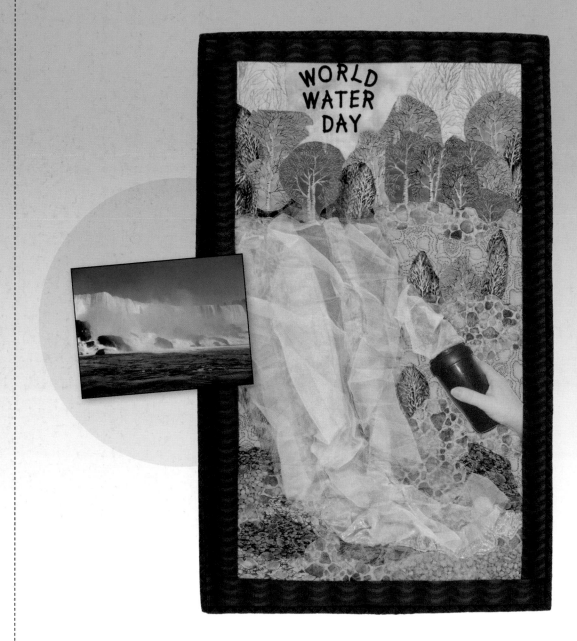

march 22nd

Everyone should have clean water.

Water is vital to the existence of people and the planet. So when I was wondering how to indicate the importance of water, I thought that a waterfall would do the job. I like waterfalls and feel that they represent the flow of water.

For most of the quilt, I fussy cut trees and rock shapes and machine appliquéd them down. Then I cut more trees and rocks and put some batting behind them and appliquéd those shapes down to give them a bit of dimension. I used netting and organza to create the water and mist. I photographed my hand holding a cup and used photo transfer fabric to copy the image onto fabric, then appliquéd that photo to the quilt.

The United Nations General Assembly declared March 22 as World Water Day to encourage the implementation of activities regarding the world's water resources. Each year, one of various UN agencies involved in water issues takes the lead in promoting and coordinating international activities for World Water Day.

Woodbridge, Virginia

Crayon Day

by Kaye McWhirter

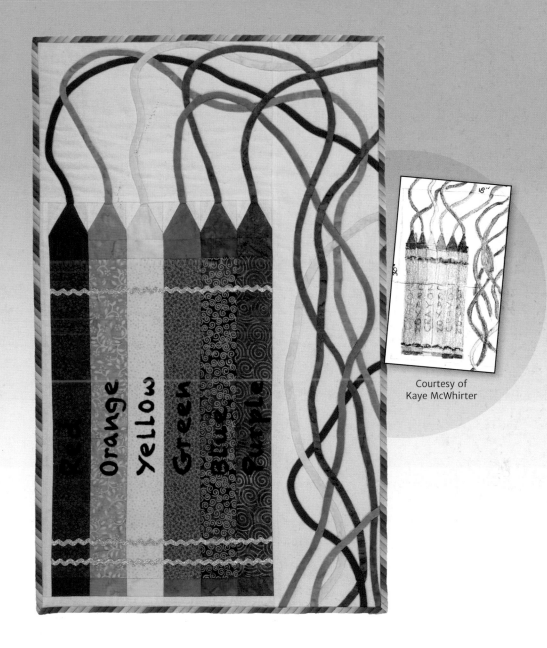

Courtesy of
Kaye McWhirter

march 31st

Throughout my life, one of my most favorite pastime was coloring. I loved to see the transformation of a simple picture into a colorful masterpiece. As such, Crayon Day was a natural selection.

My design started when my grandson and I were drawing with chalk on the driveway on a summer's day. An idea was born! That evening I took my chalk design and put it to paper. Much to my surprise, it took on a completely different design when I brought all the colors of the rainbow into the design. As such, this original design is a combination of both piecing and applique. In its construction I made one error when I cut the fabric strips for the color strings on the straight of grain instead of on the bias. The error was quickly noticed and corrected and I am still wondering how I could have made such a basic mistake.

This is the first time I ever attempted such a design project and it was a little scary at first. Once I started though, it was thoroughly enjoyable, and I found I really liked the process of putting an idea on paper, making a pattern, finding the perfect fabric and then sewing it to a completed product. I finished this quilt with a crayon shaped label.

Woodbridge, Virginia

sunday	monday	tuesday	wednesday	
		• April's Fool's Day • International Tatting Day 1	• Children's Book Day • National Peanut Butter and Jelly Day 2	
	• Caramel Popcorn Day • World Health Day 7	Draw a Picture of a Bird Day 8	Winston Churchill Day 9	
Scrabble Day 13	National Pecan Day **REACH AS HIGH AS YOU CAN DAY** 14	Rubber Eraser Day 15	National Librarian Day 16	
• Look Alike Day • Volunteer Recognition Day 20	Kindergarten Days 21	• Girl Scout Leader Day • National Jelly Bean Day **EARTH DAY** 22	National Zucchini Bread Day **WORLD LABORATORY DAY** 23	
Tell a Story Day 27	Kiss Your Mate Day **SAVE THE FROG DAY** 28	Greenery Day 29	• Hairstyle Appreciation Day • National Honesty Day 30	

| --- | --- | --- |
| Tweed Day

 3 | • Hug a Newsman Day
 • Walk Around Things Day
 • National Walk to Work Day
 (1st Friday)

 4 | Go For Broke Day

 5 |
| National Siblings Day

 GOLFER'S DAY

 10 | Barbershop Quartet Day

 11 | Big Wind Day

 12 |
| National Cheeseball Day

 17 | • International
 Juggler's Day
 • Newspaper
 Columnists Day

 18 | National Garlic Day

 19 |
| Pig in a Blanket Day

 24 | • East meets West Day
 • World Penguin Day

 DNA DAY

 25 | National Pretzel Day |
| | | |

april

DNA

DNA is the code of life! It is the genetic instructions used in the development and functioning of all known living organisms!

Adenine

Guanine

Thymine

De-oxy-ribo

Nucleic

Cytosine

Acid

Four nucleobases:
Cytosine, ...
... are

Golfers Day

by Jane W. Miller

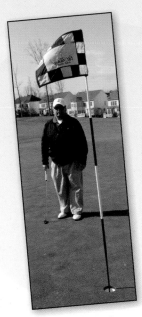

Courtesy of
Jane W. Miller

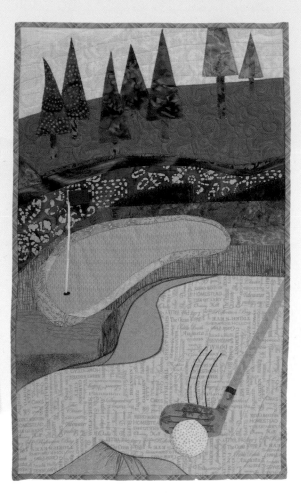

april 10th

My husband Bob is an avid golfer, so when Shannon offered the chance to "Celebrate the Day," one of my first thoughts was to look for anything golf-related. It is unclear to me why April 10 is "Golfer's Day" since my husband believes this day occurs 365 days a year. I am a golf widow, but with no complaints. It leaves me more time to quilt. I'm not coordinated enough to play golf myself, but I do enjoy the sights and sounds along the course. This quilted view is not any particular hole, but it does contain a stream, rolling hills, trees and undulating greens which are often seen along 18 holes of golf. It is my interpretation of a hole my husband could be playing, but hopefully, he would never be in the bunker, unlike this unlucky player.

Depicting "Golfer's Day" was a lengthy process. I scanned internet images, golf magazines, and actual equipment (of which there is a wide variety in my home). Unable to integrate a face or hands, I thought I'd focus on the club head, and build my idea from there. I had once thought of doing something abstract with many different angles and variations of club types, but that didn't evolve as I had hoped. Landscape quilting was unknown and hadn't been attempted prior to this challenge, but I had a piece of beige fabric with famous golf courses listed on it that was perfect for a sand-filled bunker. I examined landscape quilts at several quilt shows in the nine months prior to beginning the quilt, and shopped at vendors and local quilt shops, gathering golf-related fabrics along the way. A friend had a bag of green fabrics she planned on giving away, and the green oblong batik scraps "spoke" to me. I simply angled them into evergreens and added trunks to create the pines. The blues in the stream were also scraps from other projects. The completed project needed to be 18 by 30, and I realized I had cut some sections a bit narrow when stitching the sky, treed background, water and putting green together. So, the rock in the stream was added as a "design element" to disguise my error. Additionally, the scrap of sky was just not big enough, so I added clouds; much like a small child might draw cottony bubbles aloft. The graphite club shaft and flag pin are created using the backside of satin ribbon. The golf ball dimples were stenciled onto the fabric, then extra batting was used to add dimension. This project was an excellent opportunity to explore drafting a landscape, alternate uses of fabrics and other techniques. It was a delight to be included in this adventure.

Woodbridge, Virginia

Reach as High as You Can Day

by Shannon Shirley

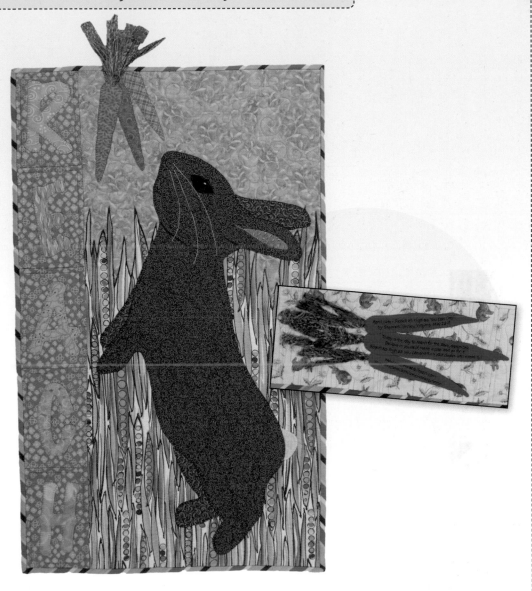

april 14th

This is the day to reach for the stars, dream big! Believe in yourself, make a plan and go for it. Reach as high as you can and turn your dream into a reality!

That's exactly what my rabbit is doing.

I drew the rabbit standing on its hind legs from a photograph and have always wanted to use it in a quilt. This seemed like the perfect opportunity. Fussy cutting the fabric for the grass gave me the background I was looking to create. Using a fabric marker, I drew along the top jagged edge of the grass to resemble the edges of the shapes in the fabric. Using my favorite

techniques—fusible appliqué with hand embroidered blanket stitch—I added the letters, carrots, and rabbit. If you look carefully, you will see I used five different prints of yellow fabric for the letters, and three different prints of orange fabric for the carrots. I also used two different brown fabrics for the rabbit. I love using multiple prints to create more interest as you get closer to the quilt. After seeing it all together, I decided the carrots needed three dimensional greenery, so I tore green batik fabric into strips because I like the rough edges for the leaves. I used batik fabric

because it doesn't have an obvious back and front. Texture was added with free motion quilting using a variety of cotton threads and monofilament. I chose to bind this piece with striped bias binding which added interest without being too distracting.

Carrots were the perfect label for this quilt. I used the same three dimensional torn greenery as I did on the front; however, I had to tack it down to hold it in place.

Woodbridge, Virginia | www.onceinarabbitmoon.com

Earth Day

by Joanne Hawk

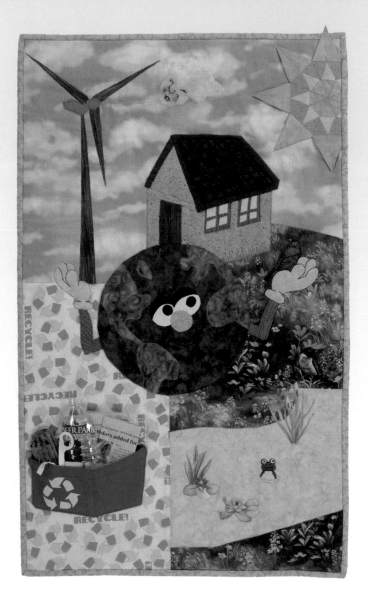

april 22nd

Growing concern about pollution and the environment generated a grassroots effort that culminated in the first Earth Day on April 22, 1970.

This quilt presents four basic areas of concern where we have made positive changes to improve our environment. Even a gentle breeze will turn the wind turbine, and golden rays of sunlight on the solar panel help with alternative energy sources. Recycling puts less strain on the landfills and fewer hazards in our rivers, streams and oceans. This creates a healthier environment for animals both on land and in the waterways. Environmentalists frequently use the life cycle of frogs to determine if the ponds, rivers and streams are healthy.

Being new to designing my own quilt, this was quite an adventure. As my ideas came together I searched online for copyright free images for creating some of the parts. I used a variety of techniques to create my quilt. Paper piecing and machine piecing, hand appliqué, machine appliqué and fusible appliqué. The recycling bin and its contents were created to have a 3-D effect. I very carefully chose my fabrics (and the placement in the case of the birds which were printed on the fabric.) It is machine quilted. I enjoyed the process and will have to design another quilt someday soon.

Earth Day has triple significance for me because in addition to celebrating Earth Day, my birthday and Girl Scout Leadership Day fall on the same date.

My tradition is to plant a tree to celebrate these events and keep a Happy Earth!

Woodbridge, Virginia

World Laboratory Day

by Beth Flores

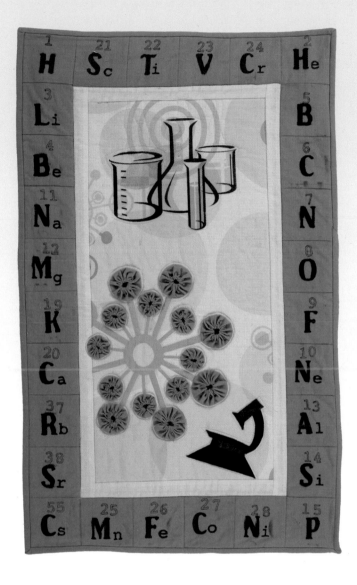

april 23rd

I really wanted to choose a holiday in April since both my husband and I, and my parents were married in April. I was thinking I could find a wedding-themed challenge until I came across World Laboratory Day. Being a lab professional myself I immediately had DNA sequences and periodic tables floating through my head. I work in a biology lab so the quilt is more focused towards that theme. I immediately had the borders set but the center was a little more challenging. I literally reached a road block when trying to design. I searched images, because I knew anything I could sew would not be as crisp as what I work with and

what I was picturing. Then I found the center background and my worries were over.

I used almost all new to me techniques, since science is all about experimentation. I have never made yo-yos before but I felt the molecule needed some enhancement. They are super easy and I find them really fun and cute. I designed my own applique for the first time and I kept it simple with squares, and was really impressed with how the microscope came out. I also stenciled the letters of the periodic table with oil paint (I don't know if I would do that again). I would have liked to have

appliquéd the letters (I feel it would have been a bit more crisp) instead of paint but I wanted to try something new. Originally the inner border had a DNA sequence stamped onto it but when it was done is was just "too much" so the border was replaced.

I really had fun with this quilt. As one of my favorite professors once said, "It brings a tear to my eye when science and art merge." Enjoy!

Front Royal, Virginia

DNA Day

by Renelda Peldunas-Harter

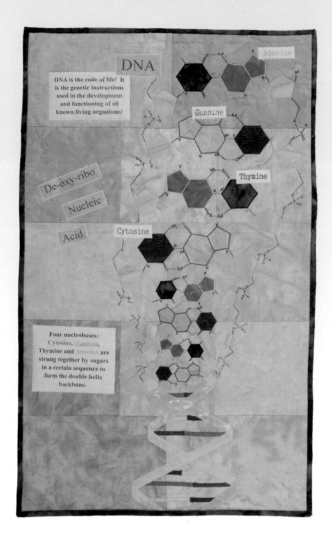

april 25th

DNA Day is celebrated 25 April because of two important milestones. The first occurred in April of 1953 when James Watson, Francis Crick, Rosalind Franklin and Maurice Wilkins published papers in the journal Nature on the structure of DNA. It was around 25 April 2003 when the Human Genome Project was declared complete. My quilt shows a simplified double-strand helix structure consisting of alternating sugar and phosphate groups with the 4 nucleotides: Guanine, Adenine, Thymine, and Cytosine in the center.

Genetics has fascinated me since Mr. Richie's tenth grade Biology class. I majored in Zoology as an undergrad and took all the genetics courses I could, as with my Masters. The time had passed for me to study and work in the field of DNA and genetics, but my fascination with the topic lingers today. I continue to read everything I can get my hands on about the subject! From that paper published in the journal Nature before I was even born, the study of Deoxyribonucleic Acid, or DNA for short, has spawned new fields of scientific study and lead to advances in all aspects of our lives today. The Human Genome Project (mapping nuclear DNA — from the cell's nucleus) gives us answers about human diseases and longevity and is the starting off point for mapping the genomes of our ancestors and ancestral cousins such as Homo neanderthalensis (Neanderthal) and several others. Mitochondrial DNA (mtDNA) is passed from mothers to sons and daughters, however, only the daughters pass it on in their X chromosome, thus enabling scientists to trace entire maternal genetic lines. A great example of genome forensics is the fate of the Russian Royal family of Tzar Nicholas II, murdered in 1918. Remains recovered in 1991 and 2003, and forensically identified in 2007 by using Queen Elizabeth's husband, Prince Phillip's mtDNA, confirm the Romanov's identity. (Prince Phillip, Tzar Nicholas II and Tzarina Alexandra are all descendent of Queen Victoria of England through their mother's genetic lines and have the same mtDNA.)

DNA is the start of many chapters in the human story, the latest one as exciting as the last!

My quilt is machine pieced. The fusible appliqué with machine satin stitch also is the quilting. I used computer printed text on fabric for the larger words and added smaller detail with a permanent fabric pen.

Purcellville, Virginia | www.quiltedcora.blogspot.com

Save the Frogs Day

by Carolyn Perry Goins

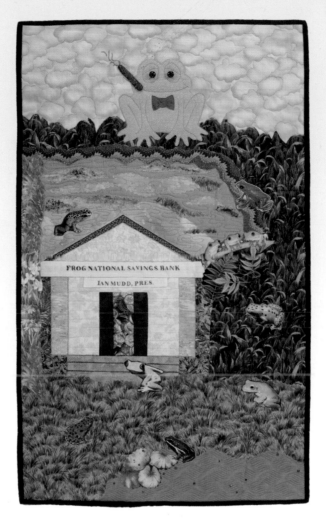

april 27th

I thought this could be a fun quilt to make. It had many possibilities for humor. I thought about a bank in the side of a mud bank as a pun on words. The frogs would come to the bank to deposit their money. I liked the idea of the humorous take on the name of the bank and fat bull frog bank president. As I began to search the internet for pictures of frogs I began to read the serious side to the reason for the day.

As a child I would catch poly wogs and tree frogs only to have my mother release them at the end of the day. She just didn't want them in the house. But in the long run it was the right thing to do. They lived for another day. Many children and adults have these memories. For today's children these memories are becoming fewer as the number of frogs are decreasing.

Many frogs are now endangered due to insecticides poisoning their habitat, changes in climate, invasive species, or the areas in which they live being destroyed for development, even diseases that are spread by human activity. The problem isn't just in one country or area, it is happening all over the world.

The loss of the frog will upset the balance of nature. They eat insects, serve as part of the food chain, and tadpoles filter our water. They eat insects that could overpopulate a habitat and thus increase diseases that might infect humans. Just another way that shows how interconnected is the balance of humans and nature. Plus, frogs look and sound cool to our children and even to us elders.

So the humor of the frogs depositing they money in the bank may now be interpreted as human contributions to preservation of the frog habitat. "If you build it they will come" is a phrase from a movie about baseball, who knew that it is true of frogs also. If you build a pond habitat frogs will find it and begin a community to benefit all of us.

The frogs traveling to the bank are photos of real endangered species of frogs. The photos were downloaded and printed onto fabrics which were stitched in place on the work. I used a fusible method of applique to construct the quilt. The quilting stitches both secured and gave contour to the quilt. Embellishments of crystals completed the work. The cigar is a stuffed tube of fabric stitched in place.

Hamilton, Virginia | www.cpgdesigns.com

sunday	monday	tuesday	wednesday	
· Bird Day · International Tuba Day · Space Day 4	· Cinco de Mayo · National Hoagie Day **OYSTER DAY** 5	National Nurses Day 6	· Astronomy Day · National Tourism Day 7	
Military Spouses Day 11	· Fatigue Syndrome Day · Limerick Day 12	**FROG JUMPING DAY** 13	Dance like a Chicken Day 14	
· National Bike to Work Day · Visit Your Relatives Day 18	 19	Pick Strawberries Day 20	National Waiters and Waitresses Day 21	
Tap Dance Day **NERD PRIDE DAY** 25	International Jazz Day 26	Sun Screen Day 27	Amnesty International Day 28	

thursday	friday	saturday
• Loyalty Day • Mother Goose Day **MAY DAY** 1	2	World Press Freedom Day 3
• National Teachers Day • No Socks Day • World Red Cross Day **IRIS DAY** 8	School Nurses Day 9	Clean up Your Room Day 10
• National Chocolate Chip Day • Police Officer's Memorial Day 15	• Love a Tree Day • Wear Purple for Peace Day 16	• Pack Rat Day • Armed Forces Day (3rd Saturday) 17
Buy a Musical Instrument Day 22	Lucky Penny Day 23	National Escargot Day
Learn About Composting Day **PAPER CLIP DAY** 29	Water a Flower Day 30	Save Your Hearing Day

May Day

by Beth Wiesner

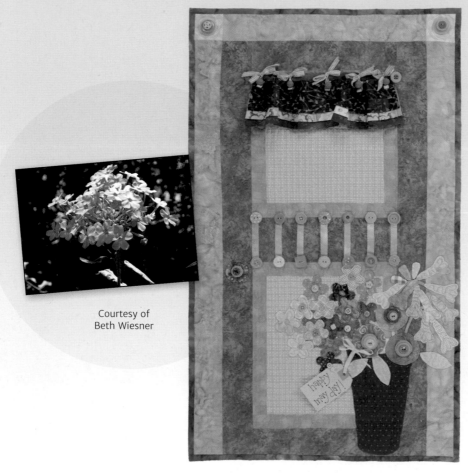

Courtesy of
Beth Wiesner

may 1st

I have always loved the idea of May Day, an old-fashioned holiday celebrated on May 1, in which you go out and pick wildflowers or flowers from your garden, put them in a little basket and secretly leave them on a friend's door before they wake in the morning. The idea of this holiday is perfect for me...I love flowers, I love little baskets, and I love surprises. But there are two little problems... I don't have a garden or a place to pick wildflowers and I don't like to get up early. In reality, every time I would read about May Day (usually in a Tasha Tudor book), I would secretly wish that someone would give me a May Day basket (yes, I realize that's extremely selfish).

So, when Shannon Shirley asked me to participate in her "Celebrate the Day" challenge, May Day was the first holiday to pop into my head. The idea for the quilt came almost immediately. I envisioned a door with a basket of flowers in front of it with a cute, "Happy May Day!" tag on the

basket. And, except for the basket (I ended up with a sap bucket for my flowers..I was reading Miracles on Maple Hill at the time), that's how the quilt turned out.

I did a little research; it turns out May 1, May Day, was first a celebration of Flora, the Roman goddess of flowers. Later it became a day that honors the Blessed Virgin Mary and is celebrated by crowning a statue of Mary with a wreath of flowers. King Charles IX of France was given a lily of the valley as a good luck charm on May 1,1561. He began to reciprocate by giving a sprig of lily of the valley to each lady of the court on May 1 each year. This is also the day when children dance around the maypole to celebrate spring, an idea that seems to have originated in Germany. May Day is also known as International Workers Day, commemorating the 1886 strike in Chicago for an eight hour work day, during which dozens of workers and police officers were killed when a bomb was thrown.

And...a day when friends secretly leave flowers by your front door.

May Day it is. I filled my bucket with the masses of wildflowers I love discovering in the spring and early summer—bluebells from Virginia farm fields, wild purple and white phlox from the foothills of the Allegheny Mountains; and pink wild roses from Presque Isle Park in Erie, one of my favorite places on earth.

You might notice that my roses are less rose-like and more round-like. My first ever design project was a floral hooked rug that I made in high school for a textile class. My mom helped me with the design, which was filled with round, pink flowers, (and my dad stayed up until midnight hooking it with me the night before it was due, something that has become somewhat of a pattern with me...). I loved that rug and it traveled around with me for decades before it fell apart. The little round roses in my bucket are an ode to that bygone rug.

Woodbridge, Virginia | www.cuckooquilts.com

Oyster Day
by Allison Avery Wilbur

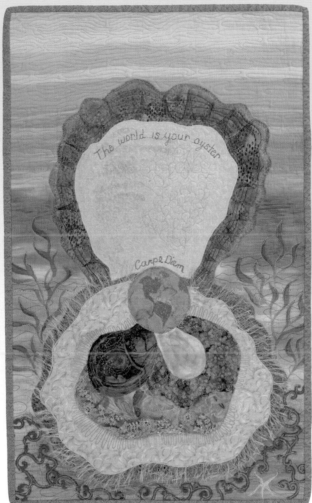

Courtesy of
Lauren Gregg

may 5th

"The world is your oyster," or so said Shakespeare in the Merry Wives of Windsor. This quilt is dedicated to a pearl of a friend who is blossoming and opening to the world, and a reminder that every day affords us a new adventure. Stretching our horizons, trying new techniques, challenging ourselves to use new methods in our art is the best way to grow as an artist. For me quilting has been a journey of discovery and connection. I have used my art quilts to talk about the status of women in the world through my project, Quilt for Change. Quilt for Change curates exhibits or art quilts at the United Nations on topics related to women. Women the world over have used stitching throughout the ages to express themselves and connect with each other. It is a language we all understand. Use your art and your voice to make the world a better place. *Carpe Diem*!!!

This was a fun piece to work on. I started with photos of oysters, and I can tell you, they aren't pretty! Conveying the gooey texture of an oyster and the hard rigid shell was challenging. To form the soft body of the oyster, I selected fabrics with different scale patterns, then added a softness by couching lace, yarn and tulle. The quilting in this section is circular and soft, the lace puffs out and the yarn fringe adds a bit of whimsey. On the upper shell, the grey fabric with lines mimics the hard ridges on the shell which are also echoed and accented with machine quilting. The metallic veins in the white fabric on the top shell are rubbed with shiva oil sticks to give an extra sheen and iridescence to the shell.

Selecting a background fabric that is a gradient, from light on the top to dark at the bottom, I added shading under the shell with fabric paint to give a sense of depth. The calligraphy style leaves were painted with a brush and fabric paint and pieces of ribbon were couched to add texture and anchor the oyster to the bottom. Finally, the background quilting undulates horizontally to suggest the gently movement of the water. My favorite part is the globe as the pearl. The batik I chose suggested the swirling oceans, the land masses are machine quilted with metallic thread and a bit of shiva paint stick gave the illusion of clouds and atmosphere. So much fun in such a small quilt!

Barrington, Rhode Island | www.allisonwilburquilts.com

Frog Jumping Day

by Mary Anne Ciccotelli

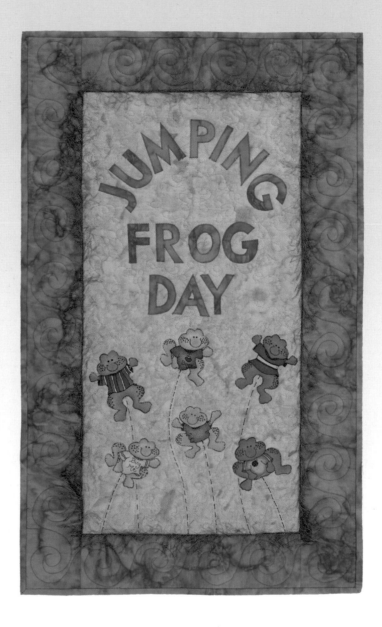

may 13th

The deadline for this challenge came at a time when I had not been doing much quilting. Much of my time was being spent dejunking and decluttering my home. Needless to say, my thoughts and energy were not fully devoted to this project since I had other pressing things on my mind. However, having agreed to participate in the project, I committed to complete it.

I decided to choose May and thought that "Frog Jumping Day" sounded fun and whimsical. It was after the deadline when I started to work on this project and so I wanted it to be something that would work up quickly. Also, having just gone through the process of cleaning out my sewing room, it was my goal to use only what I already had. I was delighted when I found a fabric with frogs on it that appeared to be jumping all over the place.

I fussy cut the six frogs from the novelty fabric and fused them on the blue background. I also fused the letters and finished the edge with machine zig zag. I added a green batik border and embellished the quilt by couching hot pink yarn to resemble an accent border. I added the jumping lines with a permanent fabric pen and finished the wall hanging with free motion quilting.

This project was a fun way to start the new year and I even completed it without having to go to the store!

Pelham, New York | www.newyorkquilter.com

Iris Day

By Kathy M. McLaren

may 8th

My choice of quilts to "Celebrate the Day" was made simply by picking holidays that fell on family birthdays. Some dates were easier to choose the theme simply because it resonated with the family. Having the opportunity to create a quilt specifically for a birthday makes the day even more special. What a wonderful way to celebrate the day!

My husband's birthday happens to be on "National Iris Day," May 8. His grandmother always had beautiful Siberian irises in her front garden, so this flower

has sentimental importance. This day also has a Japanese influence, since iris leaves and flowers are used in Japanese households to ward off evil spirits. My daughter is currently living in Japan, which makes the Japanese connection even more appropriate to celebrate this day. The actual quilt was inspired from simply piecing together a Bali Snap (Plum Pudding). I had picked this packet up at a quilt shop and thought I'd put together a simple bag, but when I saw the pieced fabric it made me think of a bed of Iris flowers. No, I did not make the

bag, it ended up in this wonderful birthday quilt! Since this image is a bit abstract, I added a silk flower to the quilt. Keep It Simple Sweetie (KISS) is still my mantra, which helped me decide on the hanging diamond grid quilting using my machine's walking foot and a beautiful variegated thread. The appliquéd iris was attached after the background was pieced, quilted and washed.

Manassas, Virginia

Nerd Pride Day

by Kathy Lincoln

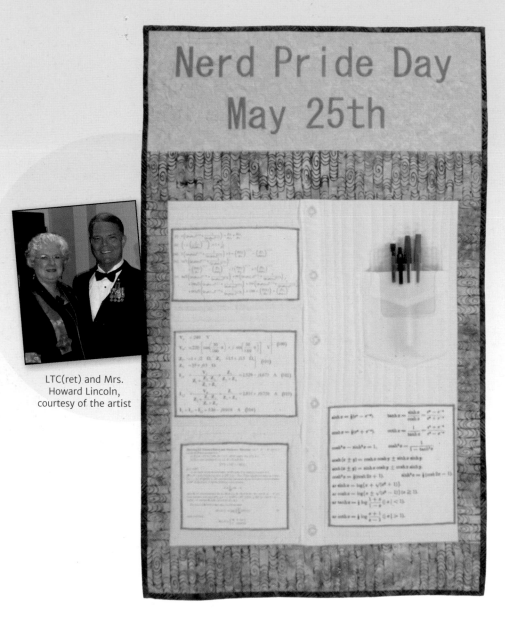

LTC(ret) and Mrs. Howard Lincoln, courtesy of the artist

may 25th

I chose the day because May 25 is my husband's birthday and it seemed appropriate. He is a civil engineer by training. When I first met him, he was something of a nerd. He has outgrown this status for the most part, but don't ask him how a suspension bridge works. You might get more information than you wanted!

Pocket protectors were equated with nerds when I was growing up so I had to use one in the quilt. I found an old white dress shirt that my boys had out grown that for some reason was still in the house. With the pocket it was the perfect backdrop for the rest of the quilt.

Complicated formulas are nerdy and so that is why they were included. I printed them on commercially available printer-ready fabric. I had originally thought of using a slide rule and old style HP calculators, but I realized that these things are not the current definition of nerdy. I would have been dating myself to a previous era.

The heading was machine embroidered (a new passion for me). The quilt was machine pieced, machine appliquéd, and machine quilted.

Burke, Virginia | www.kathylincoln.com

Paperclip Day

by Didi Salvatierra

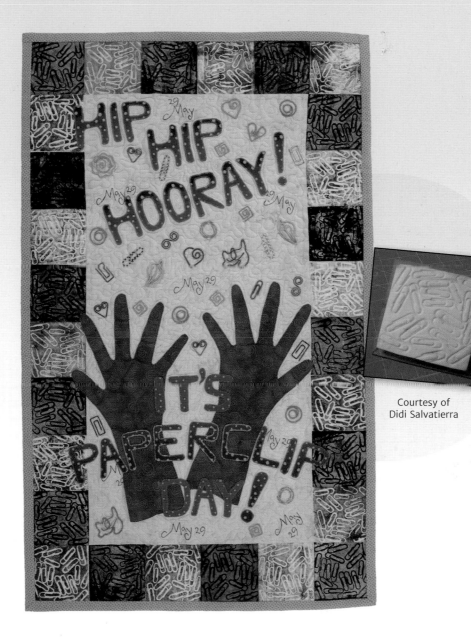

Courtesy of
Didi Salvatierra

may 29th

Paperclips were believed to be invented in 1899 by Johan Vaaler, a Norwegian inventor with a degree in electronics, science and mathematics. This is the day to celebrate the little pieces of bent wire and all of their uses.

Here are just some of the other ways to use paper clips: hair barrettes, zipper pull replacement, cherry pit remover, unclogging glue bottles, Christmas tree ornament hook, calendar holder, lock the door of a bird cage, unclog salt shakers, picking locks, money clips, cleaning pencil sharpeners, emergency fish hook, book mark, nose weight for paper airplanes,

I celebrate it every year, don't you? Not really, but when I saw this day on the list of unusual holidays, I knew it would be a fun and spontaneous quilt.

My collection of unusual paperclips would finally have a showcase. I included a handful of them on this quilt. I traced my own hands for a pattern and I cut the letters freeform out of fused fabric. I also made my own stamp using paperclips and moldable foam which was used with thinned acrylic paint to create the border. This quilt, "*Paperclips Hurrah*," is entirely machine pieced, appliquéd and quilted. It is just plain *FUN!*

Bel Air, Maryland | www.didiquilts.com

sunday	monday	tuesday	wednesday	
• Dare Day • Flip a Coin Day **1**	National Rocky Road Day **NATIONAL BUBBA DAY** **2**	Repeat Day **3**	Old Maid's Day **HUG YOUR CAT DAY** **4**	
• Best Friends Day • Name Your Poison Day **8**	Donald Duck Day **9**	Iced Tea Day **10**	Hug Day **11**	
Smile Power Day **15**	• Fresh Veggies Day • Nursing Assistants Day • National Hollerin' Contest Day • World Juggler's Day **16**	Eat Your Vegetables Day **17**	National Splurge Day **18**	
National Chocolate Eclair Day **22**	• National Columnists Day • National Pink Day **23**	• Swim a Lap Day • Museum Come to Life Day **24**	• Log Cabin Day • National Catfish Day **25**	
• Camera Day • Waffle Iron Day **29**	Meteor Day **30**			

thursday	friday	saturday
World Environmental Day	• National Yo-yo Day • Teacher's Day • National Doughnut Day (1st Friday)	National Chocolate Ice Cream Day
5	6	7
Red Rose Day	King Kamehameha Day **SEWING MACHINE DAY**	• Flag Day • National Strawberry Shortcake Day
12	13	14
World Sauntering Day	• Finally Summer Day —Summer Solstice • Ice Cream Soda Day	Go Skate Day **WORLD MOTORCYCLE DAY**
19	20	21
Forgiveness Day **BEAUTICIANS DAY**	National Columnists Day **SUN GLASSES DAY**	Insurance Awareness Day
26	27	

National Bubba Day

by Mary W. Kerr

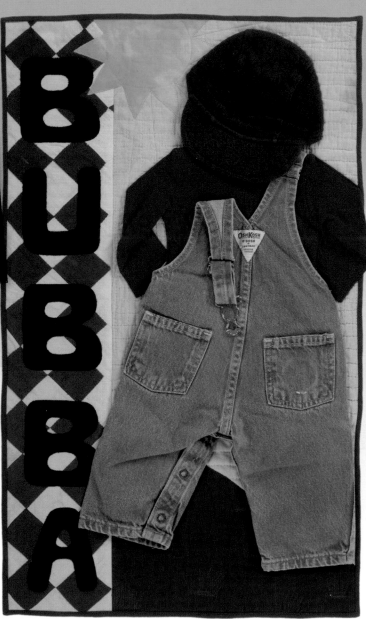

Courtesy of
Katherine
McPherson

june 2nd

In Southern-speak, Bubba is the loving nickname given to brothers and adorable little boys. My world has been blessed with two sons, Sean Thomas and Ryan James (now 23 and 25) and a grandson, Bryce Alexander who was born in June 2011. All three of these little Bubbas wore these OshKosh overalls, usually without shoes and always with a twinkle in their eye. This quilt, "*Oh Thank Heaven for Little Boys,*" was created with layers of vintage quilt fragments, blocks and clothing to include this pair of overalls. My husband insisted that we add the outline of a Skoal can onto the back pocket in the true fashion of a Southern Bubba! Bryce's and my favorite song is "You are My Sunshine, so I added the happy light that he brings into my world. Things would not be the same without our Bubbas!

Woodbridge, Virginia | www.marywkerr.com

National Hug Your Cat Day

by Shannon Shirley

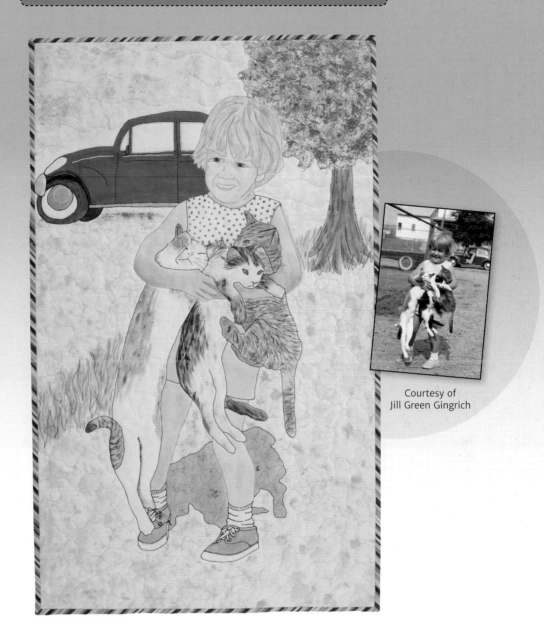

Courtesy of
Jill Green Gingrich

june 4th

National Hug Your Cat Day is the perfect opportunity to spend some time with your favorite cat. Did you know that showing your furry friend some affection is actually healthy for you? Studies have shown that hugs from animals can lower blood pressure and decrease stress. So go ahead, give your cat a big hug!

This quilt, "*Hugging the Barn Cats*," was inspired by a photograph of me when I was about 5 years old. Our family of four traveled in the red Volkswagon Bug from Colorado to Key West, Florida, and then on to Lebanon, Pennsylvania to visit my Grandma and Grandpa Gingrich. We were visiting a friend's dairy farm. I went and collected the barn cats for a hug!

I enlarged the photograph and printed it on regular paper. I was then able to trace the main shapes with a fine tip sharpie marker. Using my Tracer Projector, I enlarged the black line drawing to fit an 18" x 30" piece of paper. I used the full size black line drawing to transfer the picture to the Prepared for Dying (PFD) fabric using a mechanical pencil. After I had the drawing on the fabric, I used Tsukineko inks to paint the picture. Free motion quilting added texture and a multi colored bias striped binding finished off the edges!

Woodbridge, Virginia | www.onceinarabbitmoon.com

Sewing Machine Day

by Ann Weaver

june 13th

Although there were several attempts as early as 1790 by English, German, Austrian and French inventors to create a mechanical sewing machine, it was not until 1830 that French tailor Barthelemy Thimonnier was successful in doing so. The sewing machine was not patented in the United States until 1946. It became mass produced in 1950, but not without the drama of patent wars between Isaac Singer and Elias Howe.

I have always been intrigued by selvage! As I would cut it off and set it aside, I always thought that there had to be some creative way to make use of this scrap. God forbid that I throw anything away! Can you imagine what my sewing room looks like? Then, I began to see little items made of selvage. I came across patterns for Christmas ornaments and pin cushions! I saw a woman at a quilt show wearing a selvage vest! I even saw a skirt made of selvage at the 2013 Mid-Atlantic Quilt Show in Hampton, VA!

As I began to brainstorm my thoughts for Celebrate the Day, a word play emerged on the word "Celebrate" to "*Selva-brate*"!

So, I began to collect my fabric, selvage and various other sewing materials such as the pink tape measure and variegated threads. I began constructing my sewing machine using selvage sewn onto a pattern drawn on muslin. Then I appliquéd it, my letters, the scissors and pin cushion on to my background. I completed the binding with selvage, as well! Then, I attached the bow. Viola'!

Roanoke, Virginia

54

World Motorcycle Day

by Meghan Hurley

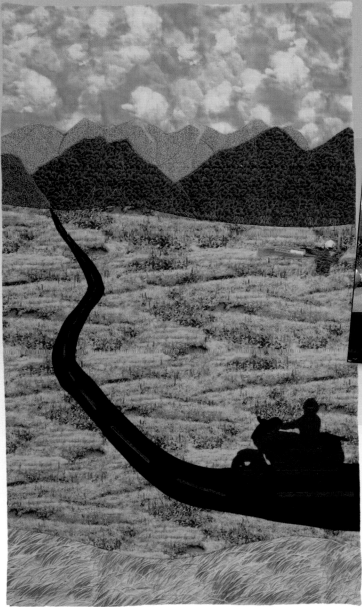

Courtesy of Meghan Hurley

june 21st

I chose Motorcycle Day because I love to ride my Honda NT 700 motorcycle everywhere. The countryside is my favorite place to go. This past riding season I got to the mountains of north central Pennsylvania, the backroads of West Virginia, tidal areas of eastern Maryland and Virginia as well as down to the Outer Banks, North Carolina.

Riding allows an unobstructed view of the world, seeing it at your own pace. The fields leading up to the mountains are so dramatic and breath taking. Riding gives me peace and serenity. My quilt for Motorcycle Day is my view of "*The Ride.*" I hope it helps others see the beauty of the world.

This wall hanging is machine pieced, raw edge appliquéd and machine quilted. I chose to face the quilt instead of binding it so that you could imagine the landscape goes on for miles!

Woodbridge, Virginia

Beauticians Day

by Jane E. Hamilton

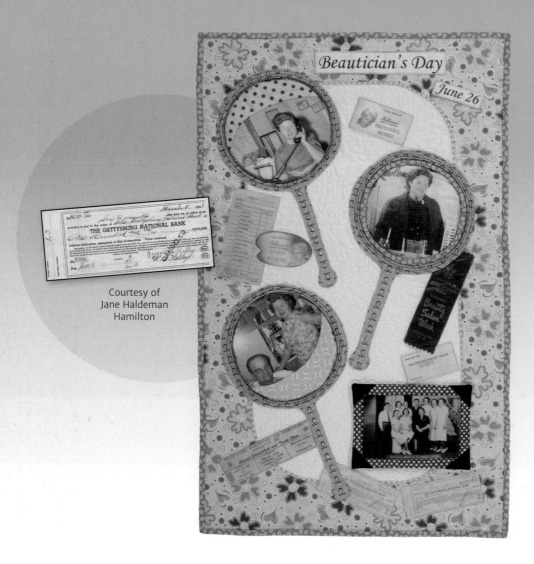

Courtesy of
Jane Haldeman
Hamilton

june 26th

Searching the days of celebration, I saw "Beautician's Day," and immediately knew this was my day to celebrate. Much of my childhood was spent in and out of the "Beauty Shop." My mother, Josephine Kelley Haldeman, was a beautician until the age of 70. She loved the work and interaction with people and they loved her. My sister and I are both licensed beauticians due to her encouragement and love.

Beauticians are not only skilled artists, cutting, curling, and shaping individual beauty, but master therapists for many of their patrons. Their listening skills, compassion and concern for others are a part of their unwritten job description. They are unseen cheerleaders, family friends, and seldom acknowledged caregivers of people in the community. Their services are invaluable to everyone!

Creating this piece allowed me to share my mother's memory and professional pride while honoring the work all Beauticians provide for families in their communities.

To begin any art piece you must have ideas. Researching and collecting subject inspiration is part of my creative process. Ideas for this piece came from vintage magazines, old business cards and other beauty advertisements and memorabilia from my mother's shop. Discovering the frame of her beauty shop mirror immediately inspired me to use the mirror shape for the images I wanted to use. Since the photos were not as large as I needed, I added complimentary fabrics to enhance the mirror images. Each mirror was constructed separately then arranged on the background.

Business cards were printed on fabric and backed with shirt tailor before fusing to the background and using a decorative stitch around the edge.

The copies of the original canceled bank loans, my mother took out with her father to pay for Beauty College are a reminder of her strong work ethic and determination to become a Beautician!

Kennett Square, Pennsylvania | www.janequilts.com

Sunglasses Day

by Kathie Buckley

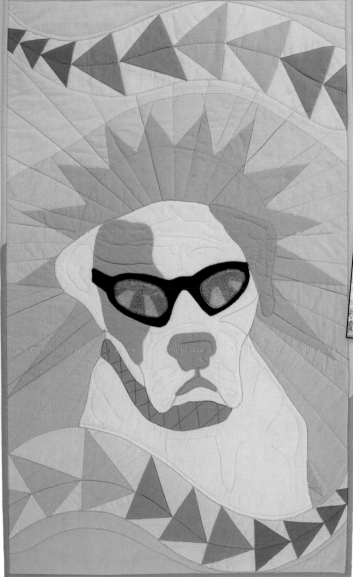

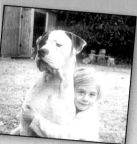

Gus and Diana,
courtesy of
Kathie Buckley

june 27th

My sewing room contains adequate supplies to create something I will like. Although it is not always possible, I find it especially rewarding if I use only the fabrics and supplies on hand, without dashing to the store. The desire to make yet another Gus quilt and the pretty box of Kona pastel fat-quarters on my sewing room shelf, made the perfect combination for this celebration of Sunglasses Day.

Gus, an American bulldog, was our beloved pet for 11 years. His rugged good looks and aloof expression made him the inspiration for a number of award winning quilts. I think he looks great in sunglasses!

Whether on the sand or in the water, the coolness of the Kona pastels was ideal, bringing relief from the hot sun.

Sunglasses Day, June 29, is sandwiched by two other days of note: Flag Day and Independence Day. The "reflection" of the American flag in the glasses gives a nod to these two more well known days. The classic, black, mirrored, aviator-style shades stand out from the paler hues of the rest of the quilt.

I am delighted with the resulting quilt, "*Sun, Surf, and Shades*"...and no trip to the store was necessary.

Woodbridge, Virginia

sunday	monday	tuesday	wednesday	
		• Build a Scarecrow Day • Canada Day • Creative Ice Cream Flavors Day • International Joke Day 1	• I Forgot Day • World UFO Day 2	
National Fried Chicken Day 6	• Chocolate Day • National Strawberry Sundae Day 7	Video Games Day 8	**NATIONAL SUGAR COOKIE DAY** 9	
• Barbershop Music Appreciation Day • Embrace Your Geekness Day 13	• Pandemonium Day • National Nude Day 14	**COW APPRECIATION DAY** 15	International Juggling Day 16	
• Moon Day • Ugly Truck Day **NATIONAL ICE CREAM DAY (3RD SUNDAY)** 20	• National Junk Food Day • National Tug-of-War Day 21	Parents' Day **HAMMOCK DAY** 22	Vanilla Ice Cream Day **NATIONAL HOT DOG DAY** 23	
Take Your Pants for a Walk Day 27	National Milk Chocolate Day 28	National Lasagna Day 29	National Cheesecake Day 30	

thursday	friday	saturday
Stay out of the Sun Day 3	• National Country Music Day • Sidewalk Egg Frying Day 4	Work-a-holics Day 5
Teddy Bear Picnic Day 10	• World Population Day • National Cheer up the Lonely Day 11	• Different Colored Eyes Day • Pecan Pie Day 12
National Peach Ice Cream Day 17	National Caviar Day 18	National Raspberry Cake Day 19
Cousins Day 24	Threading the Needle Day **CULINARIANS DAY** 25	• Aunt and Uncle Day • All or Nothing Day
Mutt's Day 31		

National Sugar Cookie Day
by Shannon Shirley

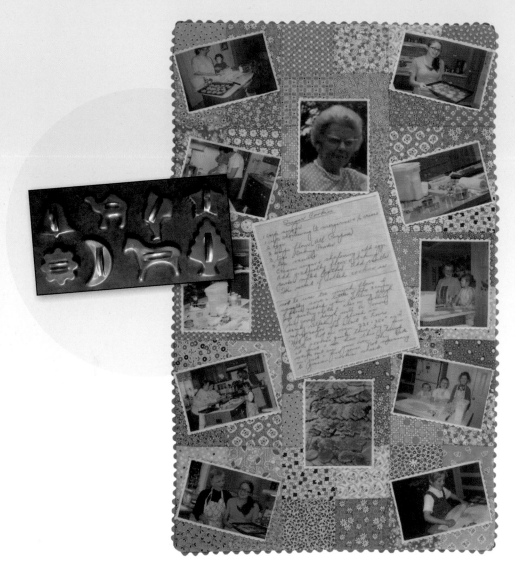

july 9th

I decided to celebrate a family tradition in my home, Aunt Florence's sugar cookies.

I searched through old photos and was able to come up with a picture of my Great Aunt Florence. Her last name is Plank but I don't remember that, just that the cookies were always referred to as Aunt Florence's Sugar Cookies. The photograph is a bit blurry but it looks just like I remember her. I also found a picture of my dad helping me roll out some cookie dough when I was three or four years old, and a picture of me practicing the skill on my own as a little girl. There are a few of my three daughters learning how to make the sugar cookies as they were growing up, and most recently Jenny (my youngest daughter) and my mum making cookies together while I took the picture!

My mum still had the original recipe card that her Aunt Florence had written out for her, when she got married, with all the extra directions so that the cookies would turn out just like hers. Thin, crisp, tender, flaky...perfect!

I decided to make a simple scrapbook quilt to feature her cookie recipe surrounded by four generations of family enjoying making them. I pieced a variety of 3½ inch squares of 1930 reproduction fabrics together randomly to create a background. I printed the photographs and recipe on prepared for printing fabric sheets by Color Plus® using my inkjet printer. The raw edges of the photographs were cut using a wavy blade rotary cutter. By fusing an extra layer of white material behind the recipe before stitching it in place, I was able to almost eliminate the background fabric shadowing through.

I quilted as I stitched the recipe and each of the photos in place. To fill the spaces around those pieces, I traced and free motion quilted cookie cutters that were my mum's from early in her marriage. I basted rick rack approximately 1/8" from the raw edges of the wall hanging before applying a facing to finish the edges.

Woodbridge, Virginia | www.onceinarabbitmoon.com

Cow Appreciation Day

by Stacy Koehler

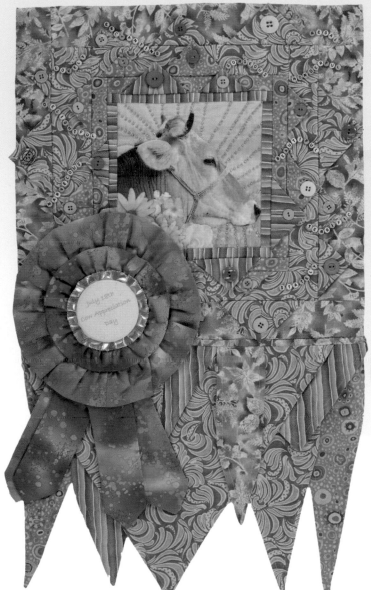

july 15th

Originally, I wanted to do a quilt about dogs, but signing up for this project late, I was advised that there were plenty of dog quilts, thank you very much, and could I please pick something else. So, looking at the list of available minor holidays, I noticed that Cow Appreciation Day was the closet day to my daughter's birthday, so cows it was.

I looked at a lot of cow photos and honestly, many lacked a certain dignity. I finally came across this photo at Dreamstime.

com and acquired it. She was beautiful and self possessed and seemed to deserve appreciation.

As I was trying to figure out what Cow Appreciation might actually look like, I kept coming back to the book *Charlotte's Web* by E.B. White, and the messages in the spider's web that saved the pig's life. The beaded words flowed from that idea.

My quilt is machine pieced and hand quilted. It has 3-D prairie points and a variety of flags along the bottom edge. It

is embellished with beads and buttons which also are part of its hand quilting.

I had a handmade ribbon that I won for Best of Show years ago. It seemed perfect for the cow, so I repurposed it. So in a way, this is a group quilt, as I did not make the ribbon. I don't know who did, so all I can do is say, "Thank you, Quilt Guild of New Jersey!"

Swarthmore, Pennsylvania

61

National Ice Cream Day

by Karen L. Dever

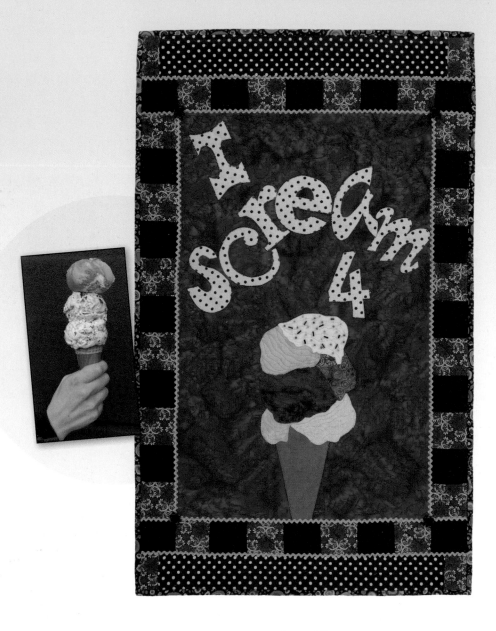

july 3rd

As I checked the special days throughout the year, I came across National Ice Cream Month and Day! It brought back memories of a job that I had while in high school and attending college. I worked at Richman's Ice Cream Restaurant and Dairy Bar in Cherry Hill, NJ. I think this is where I developed my fondness for this cold delight.

Charles E. Minches of St. Louis, MI, is credited with inventing the ice cream cone. On July 23, 1904, at the World's Fair in St. Louis, he filled a pastry cone with two scoops of ice cream to make the first ice cream cone. There is some controversy over this claim. Italo Marchiony of New York City filed a patent for the ice cream cone months before the fair opened. And, he was selling lemon ice in cones as early as 1896.

In 1984, President Ronald Reagan designated July as National Ice Cream Month and the third Sunday in July would be National Ice Cream Day. Reagan recognized how popular ice cream was in the US since 90% of the population consumed it, and stated that these two events should be observed with ceremonies and activities.

Ice cream is an anytime favorite for me; with hundreds of flavors and toppings to choose from, you can't go wrong with ice cream! Can you find the flavors hidden in the machine quilting of my quilt?

The techniques I used for "*I Scream 4 Ice Cream*" are fusing, machine applique, machine piecing, embellishments and machine quilting.

Moorestown, New Jersey | www.karendever.com

Hammock Day

by Denise Werkheiser

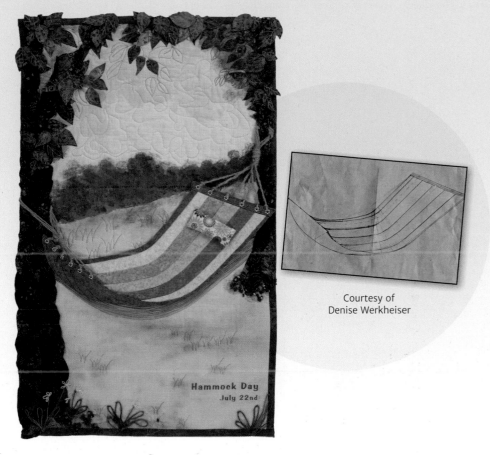

Courtesy of
Denise Werkheiser

july 22nd

When starting a new project, I usually begin by rough-sketching my design. Almost immediately my mind is wandering to what techniques to include. Sometimes, ideas percolate for days or weeks before beginning a particular aspect of a project.

I take lots of photographs to compliment my design process, providing me with not only a way to interpret and create what I see, but also to document my work.

Texture, fibers, and color play an important role to give added dimension. To work through an idea, I will combine various techniques and create small samples. I enjoy including three-dimensional aspects in my artwork by interpreting and constructing what I see.

As I looked through the various holidays to choose from, "Hammock Day" immediately brought back memories of spending time in a hammock with my sisters in our parents' backyard. Not only were there giggles and laughter between us girls, but we also enjoyed glasses of lemonade, books, and finger nail polish

painting activities. I also remember an occasional fight or two over that hammock!

Initially, I was frustrated with this quilt challenge's requirement of a vertical (not horizontal) orientation. Wanting to keep the hammock the focal point of the quilt, sketching gave me a way to play with the curve of the hammock hanging between two trees.

Next, I wondered how was I going to make a hammock look like my sketch? I chose the technique of English paper piecing which gave me the subtle curve of the stripes I was looking for.

Once the stripes were assembled, the main section was sandwiched with fleece and the darkest color of the hammock fabric was used for the backing. Machine quilting in the "ditch" was used between the stripes; top and bottom bands were assembled separately; and jute was strung thru the eyelets simulating the cording/knots of hammock strings.

Three-dimensional tree bark was assembled out of very wide bias strips of

batik fabrics. The bias strips were loosely braided together, and attached by hand; working the jute ends in around the trees.

Referring to photographs of leaves from a tree in our backyard, I created the illusion of the tree canopy above the hammock by creating three different types of leaves: free motion quilted leaves, fusible-webbed leaves, and detached leaves shaped with a water-soluble stabilizer.

One item I always like to include in my work is a spider and spider web. This tradition started when my three sons were very young, to encourage their interest in my needlework.

Summer beckons you to climb into a hammock...with a book or a beverage, or even for a nap! Through the years, the hammock has been traditionally used for a place to sleep. Today, the hammock symbolizes the ultimate leisure experience. Where you find a hammock, you are sure to find a smile!

Downingtown, Pennsylvania | www.denisewerkheiser.com

National Hot Dog Day

by Jill Sheehan

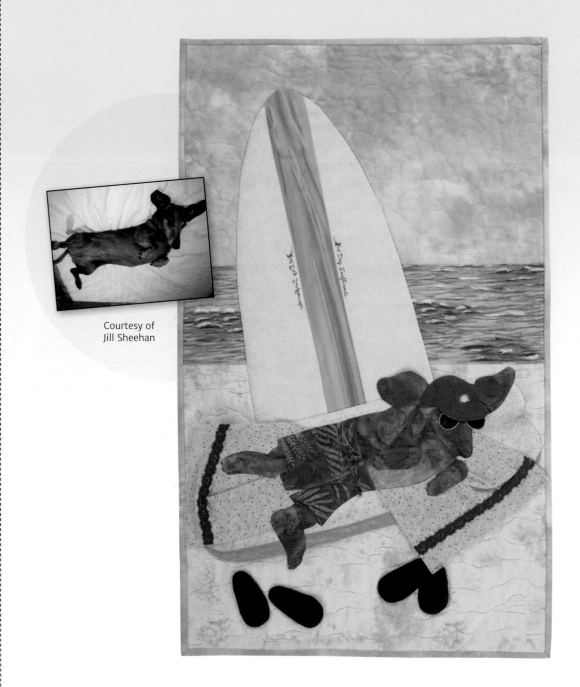

Courtesy of
Jill Sheehan

july 23rd

My first thought on picking National Hot Dog Day was not picnics and baseball games, but my sister's dachshund. She very helpfully photographed a less than cooperative Basil and I used him as my model. The bun is longer than the dog, but isn't that always the case? I originally thought of a dachshund in a pink bikini, but I couldn't do that to Basil, so he got red jams. The towel is a mustard color with red "catsup" lines and flecks of green and red "relish" in the fabric. Of course he had to have flip flops for the beach.

The surfboard and bun are appliquéd, but Basil is fused. I added details with fabric paints and used colored pencils for shading on the bun and dachshund. The flip flops are fun foam and ribbon. I chose an ocean fabric with no waves, since a surfing dog would be out catching a few if they were breaking.

Woodbridge, Virginia

Culinarians Day

by Morna McEver Golletz

RATATOUILLE RECIPE

2 large eggplant, about 2 pounds, cut into cubes
3 zucchini, about 2 pounds, cut into ¾ inch pieces
3 assorted bell peppers, about 1½ pounds, cut into 1 inch pieces
2 large onions, about 1½ pounds, quartered and sliced thinly
4 large garlic cloves, thinly sliced
4 large tomatoes, about 2½ pounds, coarsely chopped
7 large basil leaves, coarsely chopped
1 bay leaf
1 Tablespoon chopped parsley
4 Tablespoon olive oil
Salt and pepper to taste

1. Heat oven to 400 degrees.
2. Heat olive oil in a 6-quart Dutch oven over medium heat.
 Add garlic, onions, and bay leaf, stirring often, until soft and fragrant, about 10 minutes.
4. Increase heat to high. Add eggplant, zucchini, peppers and tomatoes. Season with salt and pepper.
5. Transfer to oven and cook until vegetables are tender and lightly browned, about 1½ hours.
6. Stir in basil and parsley.

Serve warm or at room temperature.

july 25th

It was easy to choose a day to celebrate. I wanted to select one in my birthday month (July) and when I saw Culinarians Day (July 25), it called my name. It's a celebration for anyone who loves to cook, whether that's as a hobby or profession. Like many, I am a foodie. I love to cook, I love to eat, and I managed to actually get a job getting paid to do that. After graduating from journalism school, I worked at the Pennsylvania Restaurant Association and the Pennsylvania Bakers Association where I was responsible for communications, including monthly newsletters. I also worked as a freelance journalist where I was fortunate to write the weekly main article on the food page for the Carlisle Sentinel on a regular basis. (Fortunate, because it involved research—i.e., eating delicious food.)

Summer is also a time of bounty for gardeners and I wanted to create something that represented the fresh produce that we use. That's why I choose to share a recipe for Ratatouille, a dish I love to make and eat, oftentimes even for breakfast!

"Summer's Bounty — Ratatouille" is made using a freeform raw edge collage technique. My design inspiration came from two sources. First, a class I took from Jeanne Benson more than 10 years ago. She got me thinking about recipe quilts. The second was a series of cards by well-known Caribbean painter Kate Spencer. Her influence infused the color and depth into the piece.

Laytonsville, Maryland | www.professionalquilter.com

sunday	monday	tuesday	wednesday
· Friendship Day (1st Sunday) · International Forgiveness Day (1st Sunday) **NATIONAL WATERMELON DAY** **SISTERS DAY** (1ST SUNDAY) 3	· National Mustard Day · U.S. Coast Guard Day · Twins Day 4	Work Like a Dog Day 5	Wiggle Your Toes Day 6
· Lazy Day · National S'mores Day 10	· Presidential Joke Day · Son and Daughter Day 11	**MIDDLE CHILD'S DAY** 12	· Left Hander's Day · Blame Someone Else Day 13
National Thrift Shop Day 17	Bad Poetry Day 18	· Aviation Day · Potato Day 19	National Radio Day 20
Vesuvius Day 24	Kiss and Make Up Day 25	Woman's Equality Day **NATIONAL DOG DAY** 26	· Global Forgiveness Day · Just Because Day · Petroleum Day 27
National Trail Mix Day 31			

thursday	friday	saturday
	• National Raspberry Cream Pie Day • Friendship Day 1	National Ice Cream Sandwich Day 2
National Lighthouse Day 7	Sneak Some Zucchini Onto Your Neighbor's Porch Day 8	National Polka Festival **BOOK LOVER'S DAY** 9
National Creamsicle Day 14	National Relaxation Day 15	National Tell a Joke Day **NATIONAL ROLLER COASTER DAY** 16
Senior Citizen's Day 21	• Be an Angel Day • National Tooth Fairy Day 22	• Chinese Valentine's Day • National Spongecake Day 23
Race Your Mouse Day 28	More Herbs, Less Salt Day 29	• Frankenstein Day • Toasted Marshmallow Day

august

Watermelon Day

by Carlene Halsing

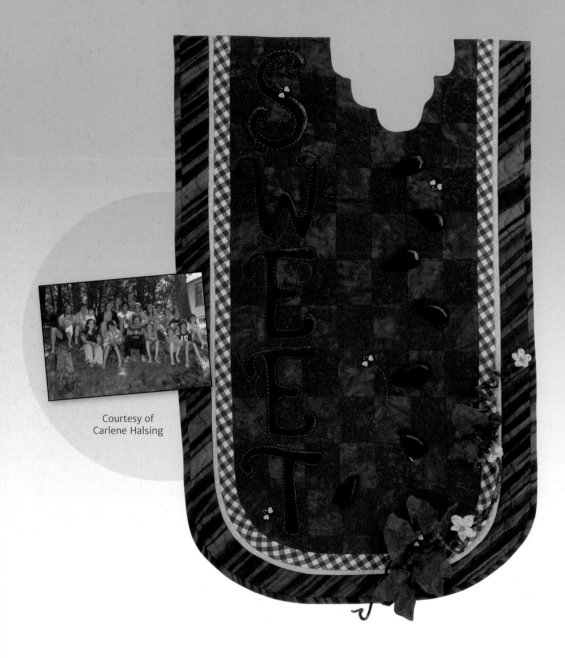

Courtesy of
Carlene Halsing

august 3rd

There is nothing better on a hot summer day, than a big, cool slice of watermelon. Summers on Lake Nipmuc with the cousins, spitting seeds and chins dripping with juice. Then after we were finished, right to the lake for more summer fun.

My quilt, "*Sweet*," was pieced using traditional methods. For the center, I used two different red batik fabrics in a checkerboard pattern for added interest.

Two bias inner borders were added to resemble the rind and a variegated dark green border represents the outer skin of the watermelon. The letters were fused in place and I added running stitch lines on them with a gel pen. I embellished the quilt with seed buttons made from foam and highlighted with paint bee buttons that I glued in place, hand stitched golden thread meander to represent the bees flying

around the sweet watermelon. To finish it off, I added the leaves and vines which are wired for a 3-D effect and small yellow flowers that I made and embellished with seed beads. The piece is machine quilted

Of course, you can't have juicy sweet watermelon with having a bite so my quilt has a big bite right out of the top edge!

Woodbridge, Virginia

68

Sisters Day

by Jill Sheehan

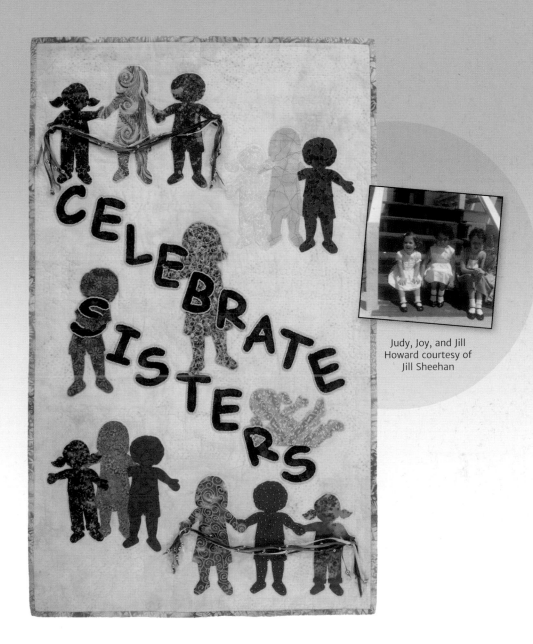

Judy, Joy, and Jill Howard courtesy of Jill Sheehan

august 1st

I chose this day to celebrate my two younger sisters and the close relationship we have now, which was not always the case! Sharing a room, fighting over the window seat, trading clothes, keeping secrets, and wishing I was an only child were all part of the deal.

While I used my family as inspiration, I did not want to be specific, since there are many bonds of sisterhood, like there are many combinations of sisters. The ribbons with the gold beads are all those special moments that bind us even closer together.

The paper doll figures and letters are fused on and the beading is done by hand. I chose yellow for the background because it is a happy color, which is how sisters and sisterhood makes me feel. The background is quilted with words I connect with sisters, words like sibling rivalry, hand-me-downs, love, and MINE!

Woodbridge, Virginia

69

Book Lovers Day

by Susan Grancio

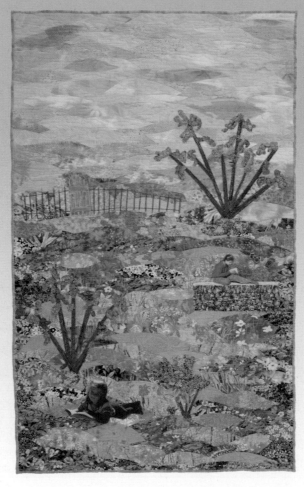

august 9th

I have been drawn to work with fibers since childhood and discovered that I could explore color and pattern through quilt-making around 1970. I created many quilts in traditional patterns as I developed technical hand and machine piecing and applique skills. Over the years, my approach and style have evolved so that I now primarily create quilts that are original works of art that interpret and express my visual impression of the world around me.

My recent work represents my interpretation of the landscape I experience near home and in my travels. The colors and patterns than I see inspire me to capture and express my visual impressions of my surroundings in cloth. Some pieces are quite literal in representing the landscape and some are much more abstract.

I use photographs and sketches to capture visual references that I then interpret in cloth in my studio. Once a quilt is started, each step of the process helps determine the next decision about the design. I primarily use commercial and hand-painted cotton fabrics in my work. The fabrics are backed with a fusible product and freely cut into abstract shapes which are then layered to obtain the effect I am seeking. I work from the top of the piece down to the foreground, building the quilt on a base of batting fused to a backing fabric. Once the design is completed, it is extensively machine quilted.

When I was invited to participate in the challenge to represent a "DAY" in a quilt, I pursued lists of likely days in search of the perfect day. Once I saw Book Lovers Day, I knew I would select that.

My two granddaughters, aged 7 and 10, are avid readers. I told them about this project and asked them for suggestions about the quilt. Both of them pondered a bit and then said I should do a quilt based on the book, *The Secret Garden*, by Frances Hodgson Burnett. Since my quilt art primarily focuses on the landscape, I decided that portraying a secret garden for reading would be my theme.

Designing a place in nature where retreating to read was the perfect activity gave me an opportunity to create a cozy garden set in the wider landscape. I included images of the two readers doing one of their favorite things.

The quilt is made with a wide variety of commercial and hand-painted fabrics, backed by a fusible web product and freely cut into shapes that are layered to create the landscape, starting with the sky and moving down to the foreground. Additional detail is layered on top and the readers are photos printed on cloth. Machine quilting and a layered edge stitched binding complete the quilt.

Reisterstown, Maryland | www.susangrancio.com

Middle Child Day

by Shannon Shirley

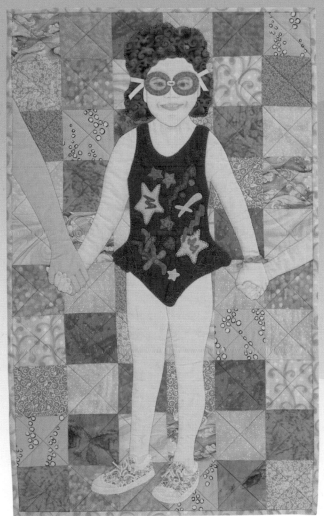

august 12th

This is the day to celebrate your middle child, who is neither the first born nor the baby of the family.

My quilt celebrates my middle daughter Emma, who is definitely ready to go play in the water. We spent much of August at the pool or water park, in the sprinkler, on the slip and slide or in a creek or ocean. I wish I had known about middle child day back when I was raising my three daughters, they would have all enjoyed another special day to celebrate!

I started with a photograph of Emma and her older sister. Emma's hands were at her side and I envisioned her holding hands with her two sisters to represent her being in the middle. I struggled trying to draw arms and hands from various photos but ended up asking a neighbor for a favor. She allowed me to photograph some of her children holding hands so I could use these pictures to help me draw the layout for my quilt.

When I got to the face, it was too grainy to use to create Emma's smile so I used her smile from a clearer picture of her at about the same age. I used a micron pen to draw the details of her face and the hands. For the skin, I sewed two layers of fabric together and turned them right side out before appliquéing them in place. The rest of the appliqué was done using a raw

edge fusible technique with hand embroidered blanket stitch on the edges.

I embellished the shoes with round elastic stitched in curls to resemble the springy shoe laces my girls used to have in their printed tennis shoes. I used blue organza ribbon on the goggles and flat elastic. The friendship bracelet was made for Emma by a friend when she was little.

The various blue fabrics represent the different water activities we spent our summers enjoying. I used a walking foot to quilt cross hatching in the background and bound the edge with one of the water prints.

Woodbridge, Virginia | www.onceinarabbitmoon.com

National Roller Coaster Day

by Shannon Shirley

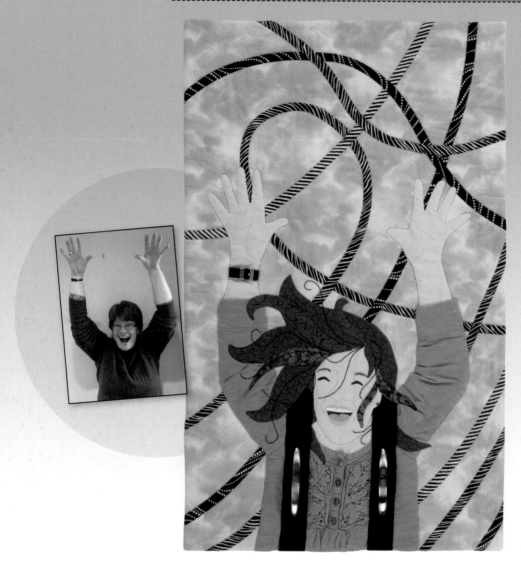

august 16th

This quilt, "*Unexpected Changes*," was originally designed for Mary Kerr's Dare to Dance Challenge. When someone cancelled on making a Celebrate the Day challenge quilt for August, I looked through the list of possible days to create a quilt to fill the space and saw that August 16 was National Roller Coaster Day, so this piece is doing double duty.

After trying to draw this from scratch, I asked a good friend to pose for a photograph so that I could draw a pattern to work from. Doing this saved me quite a bit of time. I printed the picture of her and traced a black line drawing which I then enlarged to the size I needed to fit the quilt.

I appliquéd a variety of black and white bias strips onto the background first, then added the person. The face is painted using SoSoft fabric paints. When I was looking through my stash of fabrics for the shirt, I started with a variety of fun prints but they ended up being too busy with all the movement in the background. A solid fabric was just too plain until I thought of using one of my own T-shirts that had an interesting neckline. I used needle turn appliqué on the entire piece and added a few wisps of hand embroidered hair. I had decided not to try to create an entire roller coaster but to represent it with the black harness that comes down over your head.

It needed to have handles so I headed off to the local hardware store to find some. I replaced the screws that came with the handles with very short ones so that I could just mount them on the quilt. I used free motion quilting to outline everything on the quilt and finished the edge with a facing.

Sometimes, if you are lucky to have a really good friend, you can talk them into posing for you so that creating your pattern is much easier.

Woodbridge, Virginia | www.onceinarabbitmoon.com

National Dog Day

by Phyllis H. Manley

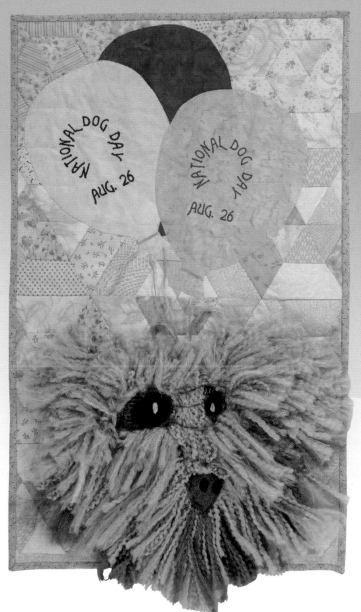

Courtesy of
Phyllis H. Manley

august 26th

I've always been a dog lover, especially those "less fortunate." Having adopted a wonderful greyhound and a rescue terrier I find a true companion in these dogs. I love my dog Maggie; she is a 5 year old mini Labradoodle, only 30 pounds and full of energy. She is very smart and does great tricks as long as a treat is involved. If I could only stop her from stealing socks.

After coming back from the annual National Quilters Association Show in Ohio, where I bought many new tools, I wanted to try the "60 degree Double-Strip Ruler" to make a kaleidoscope block. Using the ruler, I made the background, then started my design. After machine embroidering the words on the balloons, I used a machine appliqué stitch to attach them to the background. I wanted to make a dog using a method other than appliqué. After thinking about how I could replicate Maggie on a quilt, I had to make it shaggy and a wonderful buff color. Yarn was the answer! The eyes and nose were made with scraps of felt and upholstery fabric. I think I achieved what I was trying for.

Plymouth Meeting, Pennsylvania

sunday	monday	tuesday	wednesday	
		National Beheading Day	Skyscraper Day	
	EMMA M. NUTT DAY			
	1	2	3	
Neither Rain nor Snow Day				

GRANDMA MOSES BIRTHDAY | · International Literacy Day
· National Date Nut Bread Day | · Grandparent's Day
· Teddy Bear Day | · Sewing Machine Day
· Swap Ideas Day | |
7	8	9	10	
National Cream-Filled Donut Day	Make a Hat Day	Collect Rocks Day	National Apple Dumpling Day	
14	15	16	17	
· Miniature Golf Day				
· World Gratitude Day				
· National Women's Friendship Day (3rd Sunday)	· Dear Diary Day			
· Business Women's Day				
ELEPHANT APPRECIATION DAY	Checkers Day	National Cherries Jubilee Day		
21	22	23	24	
· National Good Neighbor Day				
· Native American Day | Confucius Day

NATIONAL COFFEE DAY | National Mud Pack Day | | |
| 28 | 29 | 30 | | |

thursday	friday	saturday
Newspaper Carrier Day	Cheese Pizza Day	· Fight Procrastination Day · Read a Book Day
4	5	6
· Remembrance Day · Make Your Bed Day	· Chocolate Milk Shake Day · National Pet Memorial Day	· Fortune Cookie Day · Defy Superstition Day · National Peanut Day · Positive Thinking Day **UNCLE SAM DAY**
11	12	13
National Cheeseburger Day	· International Talk Like a Pirate Day · National Butterscotch Pudding Day	National Punch Day
18	19	20
National Comic Book Day	Johnny Appleseed Day	Crush a Can Day **INTERNATIONAL RABBIT DAY** (4TH SATURDAY)
25	26	27

Emma M. Nutt Day

by Kathy M. McLaren

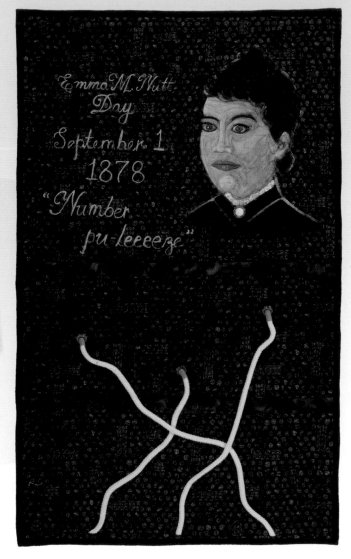

Emma M. Nutt

september 1st

My choice of quilts to "Celebrate the Day" was made simply by picking holidays that fell on family birthdays. Some dates were easier to choose the theme simply because it resonated with the family. Having the opportunity to create a quilt specifically for a birthday makes the day even more special. What a wonderful way to celebrate the day!

My oldest son's birthday coincides with "Emma M. Nutt Day," September 1. I was pleasantly surprised to learn about Emma M. Nutt, who was the first female telephone operator hired on September 1, 1878. She was quite the pioneer for women and started a career track option for young women in her time. She started in this position at the age of 18 for the Edwin Holmes Telephone Dispatch Company, later to be known as Boston Telephone Dispatch Company. She worked in this position for thirty-three years! Lily Tomlin was inspired to create her character, Ernestine, on Emma Nutt. Needless to say, the more I learned about Emma M. Nutt, the more I wanted to create a quilt to celebrate this day. I found the fabric which ultimately inspired the design of the quilt on a trip out to Colorado. It made me think of a telephone switchboard. I used Tsukineko Ink and SoSoft Paints to do the lettering and paint the portrait of Emma Nutt (image used to create the portrait was from the Wikipedia article on Emma M. Nutt). I had initially planned to use grommets and clothesline to create the switchboard, but found that the quilt did not really support the use of grommets. I ended up creating the switchboard with a hand-stitched eyelet to secure the clothesline cables. This was the first quilt completed for this challenge, which makes me realize that the fabric selection can really help or hinder the quilt design process.

Manassas, Virginia

Grandma Moses Day

by Donna Marcinkowski DeSoto

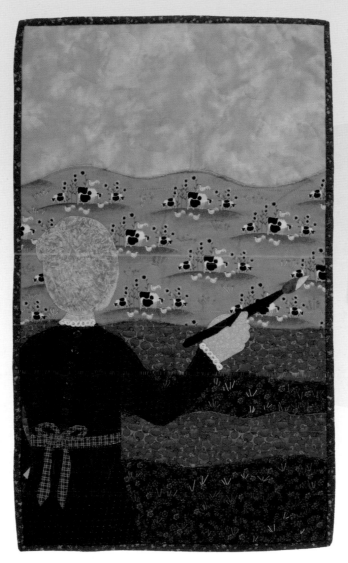

Anna Mary
Robertson Moses

september 7th

More and more I find myself wishing for simpler times, remembering what our days were like before the internet and technology just took over. This is true of everyday life and also for my art-making. While I appreciate and marvel at how times have changed, and how this has enhanced many aspects of our lives, I can't help but think that while some things have been gained, others have been lost.

I've admired the paintings of Grandma Moses since my daughter Aimee did a project on her in grade school. We went to see an exhibit in Washington, DC that featured many of Grandma's precious works, and I recall listening to other visitors fondly reminisce about the good old days. The paintings, combined with unique lively conversation, made this exhibit one of the most memorable I've ever seen.

When I chose Grandma Moses Day as "my day," I knew I didn't want to attempt to render one of her paintings as a quilt, so instead I decided to depict Grandma Moses painting a painting. My drawing abilities are lacking, so my daughter Aimee, who is a wonderful artist, helped to draw Grandma when I was in the planning phase of this project. To try to re-create Grandma's old-fashioned style, I included hand embroidery along with machine free-motion stitching. I used commercial fabrics but added various methods of surface design to achieve simple shading and color variation.

I love that Grandma Moses didn't take herself too seriously. She said, "If I hadn't started painting, I would have raised chickens." Also, "Painting's not important. The important thing is keeping busy." And "Life is what we make it, always has been, always will be."

Fairfax, Virginia | www.donnadesoto.com

Uncle Sam Day
by Carlene Halsing

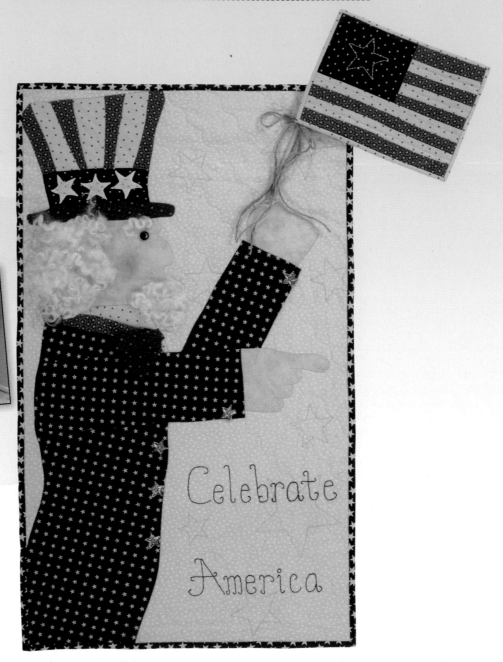

Courtesy of
Carlene Halsing

september 13th

Red, White, and Blue. Nothing signifies patriotism like Uncle Sam. My son Jesse, who is in the Navy, is a true patriot. I dedicate this quilt to him. September 13 also happens to be his birthday.

The inspiration and pattern came from a wooden Uncle Sam that my husband and

I made years ago. Uncle Sam was appliquéd onto a single piece of fabric. His hair and beard are from sheep's wool that was sheared on a farm in upstate New York, which happens to be the state Uncle Sam originated from. The flag is three dimensional and is held in place by a small buttonhole

pocket near his hand and the raffia. I made it removable for travel and packing purposes.

Woodbridge, Virginia

78

Elephant Appreciation Day

by Lisa White Reber

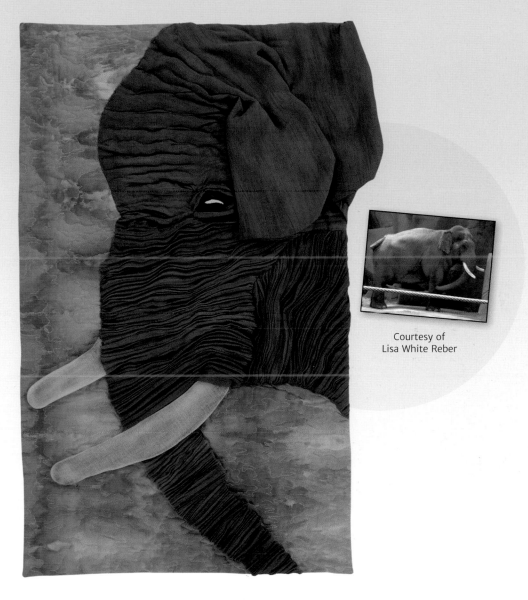

Courtesy of
Lisa White Reber

september 22nd

I have been quilting since 1994 and have been dyeing fabric since 1996 after seeing a demonstration by Fons & Porter on PBS. Dyeing fabric not only means that any color fabric can be had when needed, it also provides an artistic outlet with limitless opportunities for working with color, texture and design. In 2009, in addition to trying snow-dyeing, I began the artistic dyeing of polyester fabrics. Having the cloth as the focus of my efforts has led to quilts with the focus on the fabric. Creating the Celebrate the Elephant quilt has created a colorful marriage of dyeing, texturing and quilting.

Picking the day to celebrate with a quilt was intriguing – there are 366 possibilities! I settled on September because my birthday, my sister's birthday and my wedding anniversary are all in September. When I saw the name "Elephant Appreciation" I was hooked. I remember going to the circus when I was a kid, and my Dad got us seats at the end of the arena, close to where the animals came in. When the elephant came in, I was able to reach right out and pet him! He was bristly. I had hoped to incorporate bristles in my quilt, but instead thought of all the other unique features elephants have.

A photograph taken at the Columbus Zoo gave me a starting point, and some practice with Photoshop Elements led to a full-size sketch. Then I dyed and shibori-wrapped the polyester georgette to give it the texture for the elephant. The eye is made of polymer clay and is stitched down. A happy accident led to the discovery that polycarbonate sheet plastic will accept disperse dyes, which is how the tusks were created.

Red Hill, Pennsylvania | www.dippydyes.com

79

International Rabbit Day

by Shannon Shirley

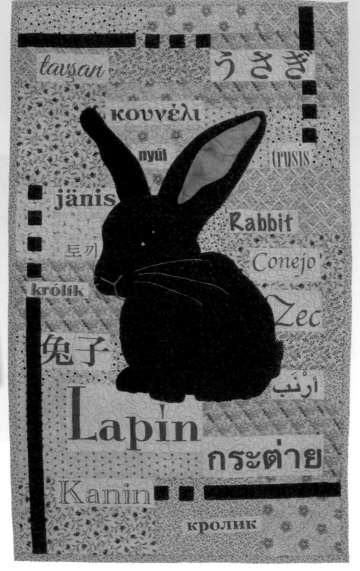

september 4th

This day is all about promoting the protection and care of both domestic and wild rabbits!

I love rabbits so this was an easy pick for me. I started by googling international words for rabbit. I chose a selection and created a document of these words in many different fonts. These documents were then printed onto fabric sheets made for using in your ink jet printer.

After cutting them out with enough extra for seam allowances, I played around with different layouts.

I then drew up a map on graph paper. Using a selection of small prints with white and beige backgrounds, I pieced the words into a single rectangle. I dyed the background for a very short amount of time, just enough to unify the variety of fabrics. Using fusible applique and hand embroidery, I added the

rabbit. The rabbit looked too small and lonely so I added the black dotted line detail and finished the quilt with a narrow binding which I had also dyed to match.

Woodbridge, Virginia | www.onceinarabbitmoon.com

National Coffee Day

by Bonnie Dwyer

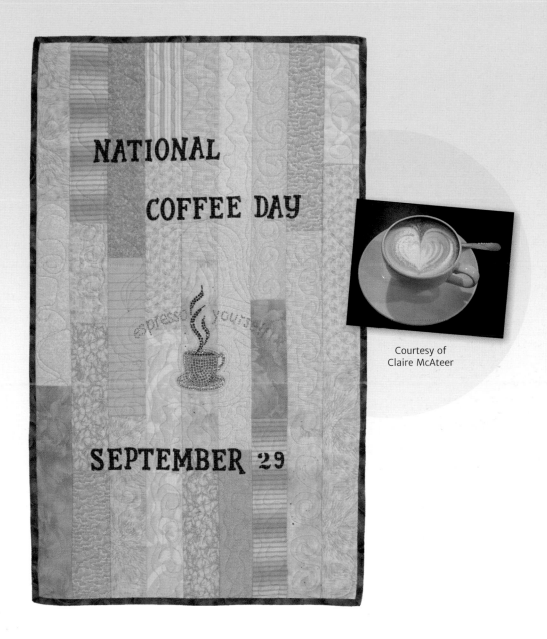

Courtesy of Claire McAteer

september 29th

From what I could find online, it appears the best part of National Coffee Day is the ability to get free coffee at many retailers. Now that's something to celebrate!

Working with fabric is in my blood. Multiple generations of women and men in my family worked with needles and shuttles of all types: sewing, knitting, crochet, and embroidery, tatting and weaving. The utilitarian and decorative textile objects they created have always been a part of my life. While I had sewn garments over several years, I didn't become a quilt maker until the 1980s, when I had a eureka moment. It was then I realized there was a reason I had been collecting all that fabric, and now I had an excuse to buy more!

I am addicted to coffee. When I discovered there was a National Coffee Day, I knew that was the day for me to celebrate in a quilt. Who doesn't love a challenge project that sends them on "the hunt" for just the right fabrics and embellishments? I created the pieced background (from my stash) to add texture and interest. The lettering was created with a scrapbooking tool for die-cutting paper; I applied a fusible to the back of the lettering fabric before cutting. The heat-set crystal coffee cup design I purchased in Paducah became the centerpiece. I free motion quilted it with steamy swirls and finished the piece with a narrow coffee colored binding.

Manchester, Maine | www.bonniedwyer.com

sunday	monday	tuesday	wednesday
			World Vegetarian Day **NATIONAL WALK YOUR DOG DAY** 1
· Do Something Nice Day · World Teacher's Day 5	Mad Hatter Day 6	· Bald and Free Day · World Smile Day 7	American Touch Tag Day 8
· Old Farmer's Day · Moment of Frustration Day 12	International Skeptics Day 13	· Be Bald and Free Day · National Dessert Day 14	White Cane Safety Day 15
Evaluate Your Life Day 19	National Brandied Fruit Day 20	· Babbling Day · National Pumpkin Cheesecake Day **COUNT YOUR BUTTONS DAY** 21	National Nut Day 22
· National Mincemeat Day · Mule Day · Mother-In-Law Day (4th Sunday) 26	Navy Day 27	28	Hermit Day 29

thursday	friday	saturday
National Custodial Worker Day **WORLD FARM ANIMAL DAY** 2	• Techies Day • Virus Appreciation Day 3	• National Golf Day • International Frugal Fun Day (1st Saturday) 4
• Curious Events Day • Fire Prevention Day • Moldy Cheese Day 9	National Angel Food Cake Day 10	Take Your Teddy Bear To Work Day **IT'S MY PARTY DAY** 11
• Bosses Day • Dictionary Day 16	Wear Something Gaudy Day 17	• No Beard Day • Sweetest Day (3rd Saturday) 18
NATIONAL MOLE DAY 23	National Bologna Day 24	• Punk for a Day • Make a Difference Day (4th Saturday)
National Candy Corn Day 30	Carve a Pumpkin Day **INCREASE YOUR PSYCHIC POWERS DAY** 31	

october

Mole Day
October 23

Avogadro's No

National Walk Your Dog Day

by Shannon Shirley

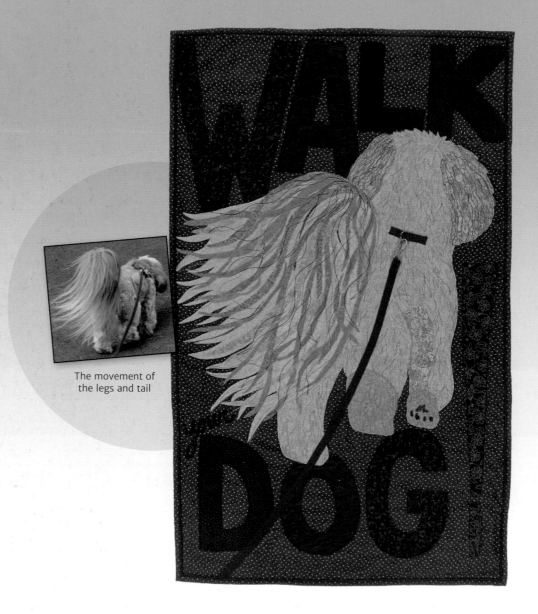

The movement of the legs and tail

october 1st

National Walk Your Dog Day was created to bring awareness to the growing problem of obesity in dogs. As people have become more sedentary, their dogs are not getting enough exercise, which effects not only their health but often their behavior.

I have always enjoyed being out walking my dog Rylie. She has such a happy perky step and when she's having fun her head and tail are held high. Rylie's long flowing tail sways in the breeze as she explores the neighborhood. I spent one morning walk photographing her for the perfect shot but ended up using a combination of photographs for my inspiration for this quilt.

I did not want the focus of my wall hanging to be the words so I chose to appliqué them in green on green so the message was there, just more subtle. I used a variety of fabrics to create Rylie's image and added quite a bit of free motion thread work for her flowing tail. The leash was made from half inch wide twill tape and a recycled buckle.

All dogs deserve to get daily exercise and mental stimulation. My mum and I will be sure to walk Rylie! The rest of you, be sure to get outside and walk your dogs!

Woodbridge, Virginia | www.onceinarabbitmoon.com

World Farm Animal Day

by Beth Wiesner

october 2nd

When I picked World Farm Animal Day, I thought it was a day to celebrate humanely raising indigenous livestock. I imagined making a barn full of happy animals representing countries from around the world. By day, I'm an English as a Second Language teacher in an elementary school, so celebrating the countries that animals come from fits right in with celebrating my students' native countries. Imagine my surprise when I discovered that the real reason for World Farm Animals Day is "exposing and memorializing the 65 billion land animals raised for food who suffer and die every year." Oh my, that's not quite so cheerful, is it? According to the website dedicated to this day, we should not eat eggs. Another website seemed to imply that we shouldn't be killing the plants either. I don't know about you, but all of that's a little extreme for me . . . I mean, where would we be without chocolate chip cookies, which are made from eggs and a variety of plant products? Not to be disrespectful, but what exactly do people who support this day actually eat?

Here is a list of several things I would like you to know about my quilt:

"Good Morning Farm," the title of my quilt, comes from a shop my Mom and I used to go to in Chautauqua, New York.

I love to read and most of my quilts contain some reference to a book I've read. Four of the animals on my quilt are characters in books: The French chicken appears in *How to Make an Apple Pie and See the World* by Marjorie Priceman. The American pig is, of course, Wilbur from *Charlotte's Web* by E.B. White (Charlotte is here too). The Swiss goat was raised by Peter in *Heidi* by Johanna Spyri, and, the Botswana cow appears in every No. 1 Ladies' book. I especially like In the *Company of Cheerful Ladies* and *Tea Time for the Traditionally Built*.

My Dad's parents were both raised on farms in Germany. My grandmother, Bertha, had to take care of the geese and she would tell my cousin and I about them while she was teaching us how to embroider. The first stitch she taught us was the lazy daisy, so if you look carefully you'll see the goose

is partially made from fabric that has happy daisies on it.

Some people buy beach houses. My parents, who live two miles from a great beach on Lake Erie, bought a former dairy farm instead. For ten or twelve years we spent many happy weekends, summers, and Thanksgiving holidays there. We didn't have any animals (unless you count the fish my Dad bought for the pond), but every visit there would include picking wildflowers as we walked down to the creek to look for crawfish. The goose has "picked" a couple of the wildflowers we used to pick — musk mallow and black-eyed susan.

Sunflowers just seem like a "farmy" kind of plant.

The name of my quilt pattern company is Cuckoo Quilts, so it seemed fitting that the goat is wearing a wreath of Swiss wildflowers called cuckoo flower.

I love polka dots and my Mom loves checks. We live 300+ miles apart and I miss being with her, so I like to include both our favorites in every quilt I make.

Woodbridge, Virginia | www.cuckooquilts.com

It's My Party Day

by Frances Carman Berrios

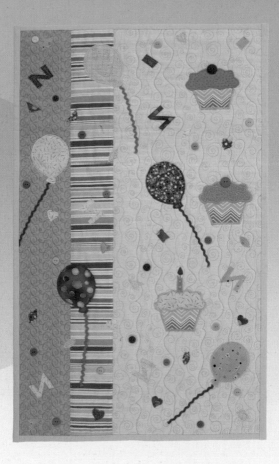

Courtesy of
Frances Carman
Berrios

october 11th

When I decided to make a quilt for Shannon's book, my first thought of celebrating a day sent me to a website to check my birthday, October 11. Wow, I was so thrilled to see that the day was declared as a party day!

My date was selected and I knew the theme for the quilt. I started checking through my quilting magazines and books that had party related patterns. The balloons and cupcakes were easily found in children's books. For a party, I immediately thought of bright fabrics with splashes of color. I had some small pieces in my 'kids' stash of fabrics but not large pieces for the background. I am always looking for an excuse to look for specialty fabric online so I checked out "party" fabrics on a website and ordered several that would coordinate with the ones I had in my stash. From there I picked out three fabrics that went well together and suggested a party theme for the background.

Now that I had my fabrics, what was I to do with them? I decided on three cupcakes and balloons scattered over the background and then, what's a party without confetti.

These ideas came to me like most ideas, at night! I keep a pen and pad next to my bed and jot down all sorts of ideas as they come along on different ongoing projects. My notes on this theme also contained party hats floating over the background. I chose not to add these, but you certainly can for your favorite child. As my thoughts came together, I realized my fabric choice would look good as tall strips using the 30 inch height required for the quilt. The design in the fabrics also dictated the direction of the background layout, the multi stripe fabric and the swirl of the yellow fabric for the look of party streamers.

Once the strips were sewn together and the background machine quilting was completed, I placed the different fused shapes for the balloons, cupcakes and confetti around the background. I stitched down the larger shapes with a machine zigzag stitch and the smaller ones were straight stitches. I wanted to have confetti circles, so buttons seemed like a good idea as a colorful embellishment.

Staying within the required size of a challenge piece does not have to be difficult. I added several inches of fabric to all four sides of my quilt before machine quilting. I marked my outside lines before all the applique shapes were fused onto the background. When sewing on the binding, I measured again and marked the edges but still kept an inch beyond the required dimensions of the quilt. After rechecking the size, I did the final cutting of the quilt edges and turned the binding to the back for sewing. I used my computer and designed a label with confetti pieces in the open spaces. My backing fabric highlighted "My Favorite Things," which seemed appropriate for the quilt theme.

Who can resist a party! The day is October 11 and it's my Birthday. Let's share some cupcakes with a few friends, throw confetti and bounce balloons. Let's celebrate the day...!

Manassas, Virginia

Count Your Buttons Day

by June Henkel

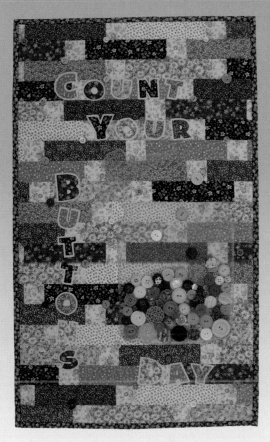

october 21st

I chose to make the "Count Your Buttons Day" quilt because thinking about buttons brought back fond memories of sitting on my grandmother's front porch and sorting through her button tin. Because the quilt is based on such memories, it seemed fitting to dig into my collection of calicos for the top. I first thought I would make a simple one patch design (like the only quilt design my grandmother ever made), but then decided to update the top using the currently popular "1600 Inch" quilt design and including the 'twist' of inserting a "potato chip," in this case, the yellow squares, between the strips.

At this point, I had a construction decision to make. Should I use the "quilt as you go" method resulting in thread tails used to attach each button showing on the back of the quilt? Should I construct the top first, then layer the top with a stabilizer and batting which would hide the thread tails for buttons? I elected to go with the latter option. In retrospect, I wish I had used the "quilt as you go" method. I believe it would have made for a more stable "quilt sandwich."

My next major decision concerned how to display my buttons. After deciding to have the buttons appear as if they were in a large glass jar, I auditioned several different see-thru materials and decided on two layers of pewter colored tulle. One layer to act as the back of the jar and provide the outline for the jar. After filling the jar with buttons, the second layer of tulle was placed over the buttons to mimic the front of the jar. In retrospect, I might have used two layers of tulle for the back of the jar to make it a little more visible.

The shape of the jar came from a picture taken of a large jar we have in the house. I traced its outline on lightweight paper-backed fusible web, and using Pat Sloan's method for raw edge applique, ironed it to the tulle, removed the paper backing, and ironed it to the quilt top. This was done twice, once for each layer of tulle. I used an iron with a non-stick coating, cleaning it on an old tee shirt between pressings to eliminate any unwanted transfer of fusible web.

Attaching both layers of tulle with machine stitching became a challenge. I discovered that the most narrow machine foot for my Singer Feather Weight (FW) was too wide to pass by the outside edges of the buttons and catch the edge of the tulle. Looking for a solution, I searched through all the feet I had for my various sewing machines. The solution was a zipper foot like the one that came with one of my sewing machines — one I hadn't used for about 25 years. So, off to the local sewing machine shop to buy a zipper foot that would fit the FW.

Although I'd never put lettering on a quilt, my design included text to balance the off-center placement of the jar. I made my fabric selections for the lettering from the same fabrics used for the quilt top, and the color selections based on contrast with the fabric on which they would be placed. However, when the prepared letters were placed on the top, they disappeared. This created another challenge. To make the letters more visible, I edged them with a solid yellow fabric.

I enjoyed bringing the elements of this quilt together and learned much in the process.

Manassas, Virginia

Mole Day
by Deborah Van Wyck

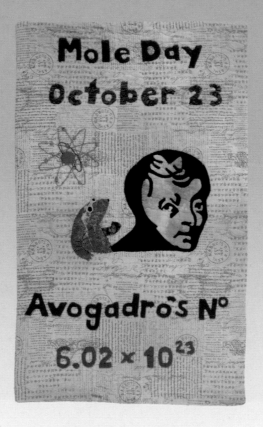

october 23rd

A basic chemistry unit of measurement, the Mole is 6.02 x 10 23 atoms or molecules, the number of particles that make up its chemical mass unit or molecular weight; equivalent to its gram formula mass as identified in the periodic table. Known as Avogadro's number in recognition of Amadeus Avogadro who conceived of the constant, the Mole is the primary way scientists convert from particles to measurable weight in the laboratory when performing calculations. Since 1991, in commemoration of Avogadro's number, chemistry enthusiasts celebrate Mole Day on October 23, from 6:02 am to 6:02 pm.

As a scientist by education, I wanted to create a quilt that honored a scientifically based holiday. I searched on line for scientific holidays, and came up with several choices, including Pi day, Pi approximation day, and Mole Day. I chose Mole day because of its focus to Chemistry, the subject my daughter teaches, so that I could donate the quilt for her classroom when completed.

When first designing the quilt, I wanted to use a scientific fabric background, applique a "nerd" Mole, Amadeus Avogadro, the person who conceived of the concept of the Mole to assist scientists with translating from atoms and molecules to laboratory measurable phenomena, and Avogadro's number, the translation constant for the Mole, as well as some chemistry symbols.

Even though I couldn't find any background fabrics with scientific symbols, I started designing the templates for the applique. I used an internet photo of Amadeus Avogadro and enlarged it by drawing squares over the image and then translating it to larger squares the size I wanted. In order to make the applique possible, I needed a simpler design and decided emphasize only the major features to create a silhouette effect. I also drew the Mole similar to the one on line representing Mole Day. I created templates for the letters that would be needed to "write" Mole Day, the date, and Avogadro's number on the quilt. I still couldn't find a suitable background fabric and time was ticking down. I really needed to begin the quilt in order to finish it in time. I was walking through a quilt store, just browsing, when the background fabric I chose jumped out at me. It is a light color and has mostly unreadable characters in it. As the concept of the Mole is often hard to understand, I thought this fabric appropriate, so purchased it and began my applique.

As I completed the applique, I noticed an empty area in the top left of the quilt and tried to think of an appropriate Chemistry symbol to use. People kept asking me to explain what a Mole was, I kept coming around to the important part of the concept which is that every atom and molecule has the same number (Avogadro's number) of particles in its molecular weight, as represented in the periodic table, so I chose to create a representation of an atom in this space. Using Rutherford's representation of an atom as a reference, I appliquéd the nucleus and embroidered electronic valence rings around it. I then appliquéd electrons onto the valence rings. As I contemplated what pattern I wanted to use for my quilting, I kept picturing in my mind the periodic table, which seemed to be about the same size, turned sideways, like the quilt itself, so I drew out how it would look superimposed on the quilt in quilt stitches. It fit perfectly, so I decided to quilt the periodic table into the piece.

Woodbridge, Virginia

october 31st

Choosing a day to celebrate is harder than it sounds.

At first, I looked at October 8, which is my birthday, for inspiration. October 8 is also National Kick Butt Day. My friends thought that was hilarious! Apparently, I'm well qualified to address that topic. (I have had friends invite me to help them get past creative blocks in their art, and so I guess I do know how to kick butt.) The hard part wasn't finding a day that resonated with me; the hard part was finding a day that resonated and for which I could create a compelling visual image.

Ultimately, I chose "Increase Your Psychic Powers Day." I love that it falls on Halloween and I was sure I could concoct a visual image I liked. Since the quilts in this challenge are fairly small, I wanted to make every inch count. I also wanted to work with familiar techniques and to have fun.

I always start with research, and so I did an internet search for images based on the keywords "Psychic Power." I chose a few that I liked and looked for the common elements. What did they have that appealed to me? Words. I love to incorporate words in my art. For this quilt, I decided to recreate a window with a neon sign advertising psychic readings. Then, because I can't resist a pun, I used my "QuiltWriting" technique to add psychic reading to the background.

For the background, I did a little more research and compiled a list of words, phrases, and instructions related to increasing your psychic power. Then I freemotion quilted those words onto the black background in a very dark grey thread. I wanted the viewer to see texture from afar and to be rewarded with words to read from a shorter distance.

My friend Judy Gula gave me the perfect shiny purple fabric to use for the neon sign. Originally, I planned to fuse this thin fabric directly to the background, but a test piece showed that the texture of the QuiltWriting on the background would show through and distract from the sign text. Black wool felt was the answer. I fused the letters to the felt, cut them out with a scant quarter-inch margin around each letter, and then sewed them to the quilt one by one. This solution was so much better than the original plan, because the words were now raised and smooth.

There are those who believe everyone has psychic powers, which can be increased with the correct intention and practice. I compiled a list of actions one can take if they want to increase their own psychic powers, and I used QuiltWriting to include them. Of course, if you were psychic, you'd already know that.

I love to make quilts. I appreciate the textures and colors, I think about the construction, and I enjoy the process. My favorite part of quilt making is working through the design challenges. I think quilts are often better than the original plans when we come up against challenges and we have to revise our plans.

Fairfax, Virginia | www.moonlightingquilts.com

sunday	monday	tuesday	wednesday	
· Look for Circles Day · Deviled Egg Day 2	· Housewife's Day · Sandwich Day 3	King Tut Day 4	Gunpowder Day 5	
CHAOS NEVER DIES DAY 9	Forget-Me-Not Day **UNITED STATES MARINE CORPS DAY** 10	· Veteran's Day · Air Day **GOOD CUP OF TEA DAY** 11	Chicken Soup for the Soul Day **NATIONAL GAMING DAY** 12	
Have a Party With Your Bear Day **BUTTON DAY** 16	· Take a Hike Day · Homemade Bread Day · National Adoption Day (Sat. before Thanksgiving) 17	Occult Day 18	Have a Bad Day Day 19	
· Black Friday · Eat a Cranberry Day 23	 24	National Parfait Day 25	Shopping Reminder Day 26	
Stay at Home Because You Are Well Day 30				

thursday	friday	saturday
		• All Saint's Day • Plan Your Epitaph Day 1
Saxophone Day **MAROONED WITHOUT A COMPASS DAY** 6	Bittersweet Chocolate with Almonds Day 7	• Cook Something Bold Day • Dunce Day 8
• Sadie Hawkins Day • World Kindness Day 13	• Operating Room Nurse Day • National Pickle Day 14	• Clean Out Your Refrigerator Day • America Recycle's Day • National Philanthropy Day 15
• Absurdity Day • Beautiful Day • Universal Children's Day 20	• False Confessions Day • World Hello Day 21	Go For a Ride Day 22
Pins and Needles Day 27	Red Planet Day 28	Square Dance Day

A Good Cup of Tea...

Always use fresh water... Bring to a full boil...

One rounded teaspoon of tea for each cup, plus one for the pot...

Marooned Without a Compass

by Vania J.Root

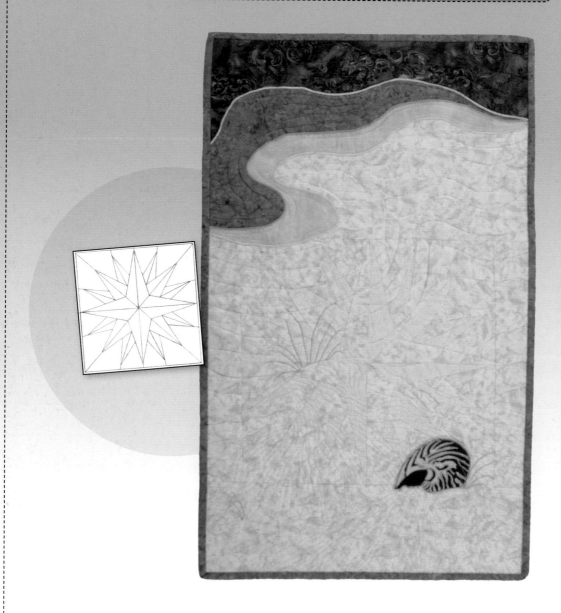

november 6th

Have you ever had one of those moments, days, months, seasons or years — a time when you felt lost and didn't know which way to turn? When I was asked to do a "Celebrate the Day" quilt, it surprised me that there was such a day as "Marooned Without a Compass." But this was exactly how I was feeling at the time — lost, not knowing which way to go. You see, my husband and I were planning to move and then suddenly his relocation fell through.

So we immediately took our house off the market, which was just hours away from an offer being accepted.

During times like these, when I feel marooned, I have learned to rely on my faith in God. He tells me in Hebrews 13:5, "for he has said, I will never leave you nor forsake you." This is what I am trying to convey in this quilt. Look closely in the sand, there you will see a Mariner's Compass block. The shell may feel marooned, but the compass is there to guide the way, just as God guides my way.

I used paper piecing to make the mariners compass and then incorporated it into the sand. Inspired by a picture, I played with the fabrics for the wet sand at the water's edge and the water itself. Then I applied it by using the satin stitch.

Woodbridge, Virginia

Chaos Never Dies Day

by Pauline Davy

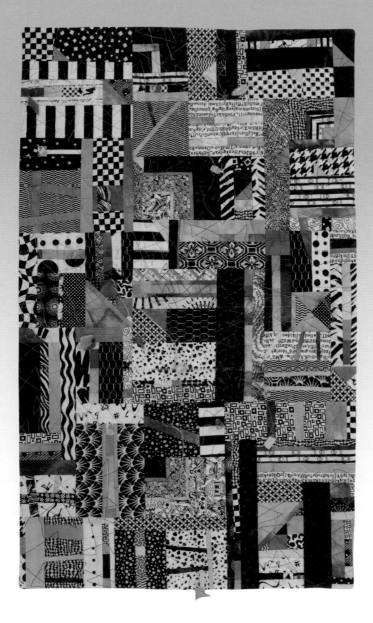

november 9th

The world isn't just black and white. There is no perfect line from A to B. Our lives are a chaos of many pieces. Dangling bits of things undone and shot with bits of color. We journey on and delight in the bright pieces and cope the best we can with the dark parts. All the while, making the best of this chaos that never dies.

I was working on a much larger quilt built up of many black and white pieces interspersed with small bits of hand dyed fabrics when Shannon suggested the design would be the perfect piece for "Chaos Never Dies Day." While there weren't any problems piecing, the process is very time consuming. Some of the pieces are as small as 3/4 inch

wide leaving 1/4 inch or less showing. There is no pattern since all of it was pieced intuitively as I went along. I do like the dangling threads and other loosely attached bits of fabric. Imperfect, much the way our lives are.

Manassas, Virginia

Marine Corps Birthday

by Michelle Carroll

LCPL Domonic J.
Carroll, courtesy of
Michelle Carroll

november 10th

The United States Marine Corps was founded on November 10, 1775 at Tun Tavern (yes, in a bar) in Philadelphia, Pennsylvania during the American Revolution. Marines are proud and honored to call themselves United States Marines, and no matter if they are still active or no longer in, it is known "Once a Marine, Always a Marine." November 10 is every Marines second birthday and is celebrated every year by all Marines, especially those still on active duty with a Birthday Ball to celebrate. Marines celebrate with a traditional cake cutting ceremony with the first pieces of cake served to the oldest Marine in the room and then the youngest Marine in the room.

My family is a proud Marine Corps family. My grandfather was a Marine during World War II. My husband served for eleven years before being medically discharged due to injuries he received in both Iraq (Operation Iraqi Freedom) and Afghanistan (Operation Enduring Freedom.)

This wall hanging is a collage of different things representing not only the Marine Corps but also my husband. His rank was an E-5, Sergeant and he earned two purple heart medals. The helicopter is Osprey. The Iwo Jima raising of the United States flag on Mt. Suribachi on February 23, 1945 during World War II. In the star of the United States flag is a button from my husbands uniform.

This wall hanging was machine pieced and machine appliquéd, embellished with beads, buttons, and a flag. It was machine quilted by Aurora Quilts in Manassas, Virginia.

Woodbridge, Virginia

Good Cup of Tea Day

by Shannon Shirley

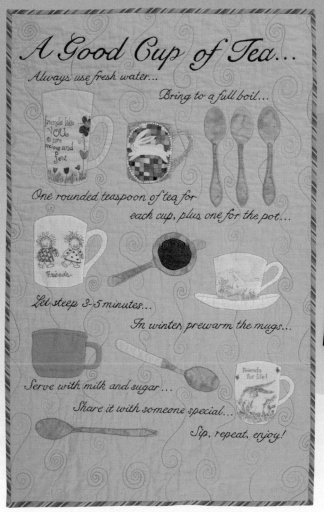

november 11th

This day is about celebrating the life and legacy of Sister Catherine Elizabeth McAuley, an Irish nun who founded the Sisters of Mercy in 1831. When Catherine was dying, she requested that the sisters have a good cup of tea when she was gone. Today that request continues to be honored by people around the world.

I never imagined that the gesture of a cup of tea could mean so much. Tea is comforting, it can help calm you down when you are stressed, it can perk you up when you are sleepy, it can comfort you when you are sad, it can warm you up when you're chilled. It can improve your outlook on many situations.

I have such fond memories associated with hot tea. I have enjoyed many a cup of tea with close friends and family. While creating this wall hanging I enjoyed thinking about many of these people and the moments we have shared together.

I started by printing the various pieces of text and cutting them into strips. While arranging them in various layouts on the 18" x 30" piece of brown paper I decided to get some of my favorite mugs to include in the design. When I had come up with a pleasing layout I added spoons and a strainer to add interest and fill some of the remaining spaces.

Now I had to turn this into a wall hanging. I traced the text onto the background fabric using a permanent fabric marker, and I used fabric markers to recreate the pictures on five very special mugs. I decided to use needle turn applique on all the applique pieces on this quilt.

First I free motion quilted around the edge of each applique piece using monofilament. I then used black cotton thread to quilt the text. The background was quilted with steamy swirls using a variegated cotton thread. I finished the piece off with a multi colored striped bias binding.

When I see this quilt, I see so much more than mugs, spoons, and the directions for making a good cup of tea. Each of the items pictured have a story or a memory to go with them. Some of those memories are sad, but sharing them with special people in your life while enjoying a good cup of tea warms your heart.

Woodbridge, Virginia | www.onceinarabbitmoon.com

National Gaming Day

by Iris Graves

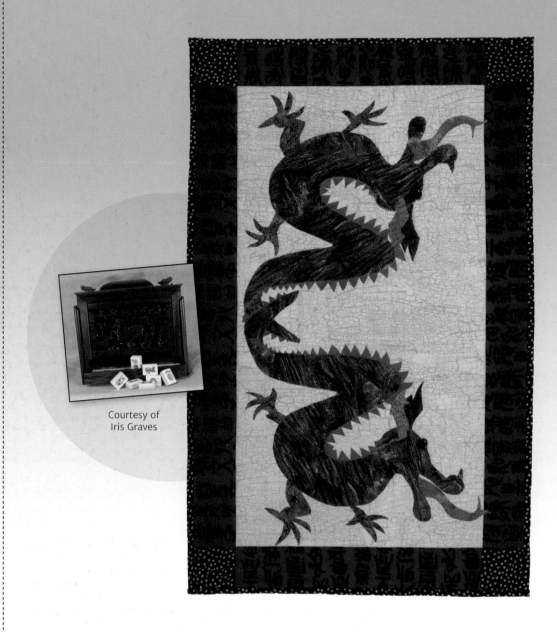

Courtesy of
Iris Graves

november 12th

My quilt celebrates National Gaming Day. This day was started by the American Library Association in 2008 as a way to reconnect communities through their libraries. Games are not just recreational, they are educational and social as well.

I learned to play Mah Jongg, an ancient, chinese tile game, this year. The game has won tremendous popularity in the US in recent years...careful: this game seems to have an addictive quality! The American version is played somewhat differently than the Asian version.

The Mah Jongg tiles are divided into three suits: Cracks, Dots and Bamboo (often called "Bam" for short). I chose the fabrics for the quilt background and the border with that in mind. Each suit is made up of numbered tiles (1–9) and tiles showing dragons—hence the object of my quilt became the dragon. To learn more about this game, visit the National Mah Jongg League's website.

I used fusible applique for the two dragons and then added the border with corner squares. I do not usually design my own quilts so this was a challenge for me but I enjoyed the process. I think I will add the word Mah Jongg to the background at some point.

I absolutely love playing this game and for Christmas my children surprised me with a beautiful chest which contains a Mah Jongg set.

Woodbridge, Virginia

Button Day

by Merry May

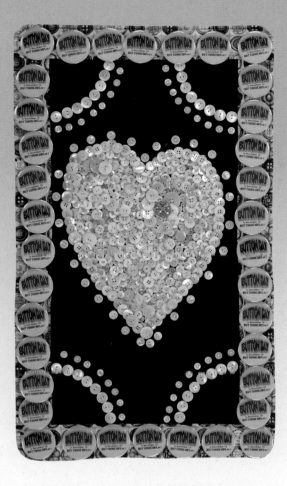

november 16th

Button Day celebrates everything button! This includes both the traditional sew-on kind as well as the pin-back type. Buttons are like little jewels and have fascinated people since they were first invented.

I have always loved buttons. They are my version of little jewels that I can afford to buy, and can run my fingers through. I always feel rich when I do that for some reason.

My husband, Joe, mentioned to me one morning that there was a classified ad in the newspaper offering a warehouse liquidation sale of "fabrics, notions and buttons" in a nearby town. I called my best quilting buddies, Lois and Lorraine, for an emergency gallivant. True friends that they are, they agreed to go with me to check out this warehouse.

When I called for directions, I asked about the ad that mentioned buttons. He replied, "Buttons! I've got MILLIONS of buttons!" When Lois, Lorraine and I arrived at the unheated warehouse, we first explored the bolts of fabric on the cutting tables and concluded that these were not what we were looking for, so we went on to the buttons. When Stan noticed we were investigating the buttons, he invited us into the storage area behind the cutting tables. There we discovered huge unopened boxes of buttons, several of which had Bicentennial logos on them. Other boxes were full of smaller boxes of buttons in a wide variety of sizes and colors. Most were marked with the original quantities: 5 gross (a gross is 144); 20 gross, 24 gross, etc., depending on the size of the buttons. That day I did not buy any buttons, but went home and spoke to my husband and we decided that if we could get a good deal we would buy all of Stan's buttons. We came to an agreement with Stan on a price and made arrangements to pick up our buttons.

When we went to get them, we brought two (half-ton) pickup trucks and a minivan. By the time they were loaded up, both trucks were nearly doing "wheelies" from being loaded down so much. The minivan was also riding a little low from the weight it was carrying. There was no room for the display cabinets or the filing cabinets, so we still needed to make another trip to pick those up, as well as several more huge boxes of buttons that we just couldn't squeeze into our first trip.

As we were hauling the boxes into the living room so we could start repackaging them, the bottom of one of the boxes burst just outside the house. There were seven of us there, and we all looked down at the pile of small, white shirt buttons and said, "*I'm* not picking them up!" So, to this day, we have buttons in our driveway. They sparkle in the sun, and are a source of entertainment when people with children come to visit.

So, if you need buttons, you know who to call now, don't you?

Tuckahoe, New Jersey | www.merrymayhem.com

sunday	monday	tuesday	wednesday
	• Eat a Red Apple Day • World Aids Awareness Day 1	National Fritters Day **NATIONAL MUTT DAY** 2	National Roof Over Your Head Day 3
• Letter Writing Day • National Cotton Candy Day • Pearl Harbor Day 7	National Brownie Day 8	• Christmas Card Day • National Pastry Day 9	Human Rights Day 10
National Bouillabaisse Day 14	National Lemon Cupcake Day 15	National Chocolate Covered Anything Day 16	National Maple Syrup Day 17
• Humbug Day • National Flashlight Day • Look on the Bright Side Day 21	National Date Nut Bread Day 22	Roots Day 23	National Egg Nog Day 24
Card Playing Day 28	Pepper Pot Day 29	National Bicarbonate of Soda Day 30	• Make Up Your Mind Day • Unlucky Day 31

thursday	friday	saturday
Santa's List Day **4**	**BATHTUB PARTY DAY** **5**	St. Nicholas Day **MITTEN TREE DAY** **6**
National Noodle Ring Day **11**	**THE FEAST DAY OF OUR LADY OF GUADALUPE** **POINSETTIA DAY** **12**	· Ice Cream Day · Violin Day **13**
BAKE COOKIES DAY **18**	· Look for an Evergreen Day · Oatmeal Muffin Day **19**	Go Caroling Day **20**
National Pumpkin Pie Day **25**	· Boxing Day · National Whiners Day **26**	· Make Cut Out Snowflakes Day · National Fruitcake Day

december

Mitten Tree Day

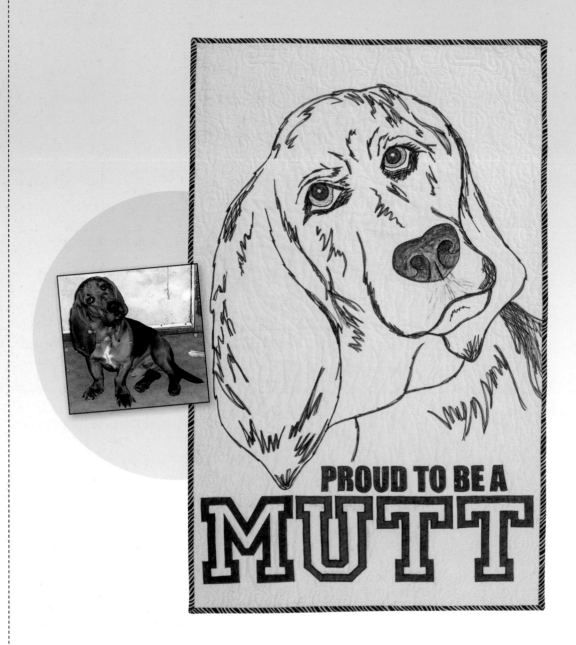

december 2nd

National Mutt Day was created in 2005 by Colleen Paige, who is an animal welfare advocate. The day is about saving and celebrating mixed breed dogs. It has been said that "once you go mutt, you never go back."

In January of 2009, I rode with a friend and his children from Virginia to Ohio to adopt Gilbert from Rose's Rescue. He is a Bloodhound/Basset hound mix. On the long drive to Ohio, I took the photo below and began a pencil sketch to pass the time.

I was rather happy with the sketch and framed it and gave it to Gilbert's new family as a memory of the trip.

When I saw that there was National Mutt Day, I knew Gilbert would be perfect! I enlarged the drawing I had made with a projector and drew it full size on paper. I then traced it onto bleached muslin using fabric markers. I enlarged the words and traced those in fabric markers as well. Just to be safe, I heat set the entire piece, but it still bled a little around the letters when

I sprayed it to erase the blue water soluble quilting lines I had drawn on the quilt. I often use fabric markers and rarely, if ever have problems with bleeding. Free motion quilting using cotton thread and clear monofilament adds texture to the wall hanging. A bias black and white striped binding was the finishing touch.

So remember, if you have room in your heart and your home for a dog, adopt a mutt, you'll never go back!

Woodbridge, Virginia | www.onceinarabbitmoon.com

Bathtub Party Day

by Angela Robertson

december 5th

Bathtub Party Day, December 5, should remind you of the luxuries of the past when we spent the time to take a bath instead of rushing through a shower. I personally find the timing of the holiday perfect, as I think it is a good time to relax and reflect during the crazy Thanksgiving to Christmas season. My idea of a bathtub party may be different than a rubber ducky (good book, glass of wine and music), but whatever your idea of the perfect bathtub party is, be sure to celebrate!

I decided to participate in this challenge from Shannon to break away from working on published patterns. Designing something myself is definitely outside of my comfort zone. After brain storming some ideas, I began to sketch my ideas on freezer paper cut to the final size of the quilt. One of my biggest challenges when designing my own quilts is the scale of the objects in my quilt.

I have found that sketching real-size samples of my quilts makes it easier to assess the best size of each object in the quilt.

This quilt used some new techniques for me, English paper piecing and grommets. I took a beginning English paper piecing class while designing this quilt. After that class, I just knew that I wanted to use this technique to hand piece the hexagon tiles behind the bathtub. I wanted the look of the only one color of tiles, but struggled with how to still make the hexagons look like they were pieced. In my stash, I found some leftover batik backing. The design motif varied across the width of the fabric. I decided to cut the fabric for the tiles across the entire width of the fabric so that I could take advantage of the different textures. After piecing over seventy hexagons for the background, I am happy

to say that I still love English paper piecing.

I had decided early in the design process to use the rubber ducky as the partygoer in the bathtub. However, I still had to figure out how to incorporate the shower curtain in a creative way. As I wandered on a visit to the craft store, I saw grommets. It dawned on me that I could use grommets as the holes in the top of the shower curtain, string them through something that would look like a curtain rod, and then it could just hang on the quilt. I found the silver ribbon on the same trip to the fabric store, and brought them home to start figuring out the logistics. I wanted the curtain placed such that the duck was exposed, but it looked like you were stealing a quick look. After trying several different techniques I settled on placing the curtain exactly where I wanted it, and sewing down the "curtain rod" so that the curtain would be secure.

Bristow, Virginia

Mitten Tree Day
by Paula Golden

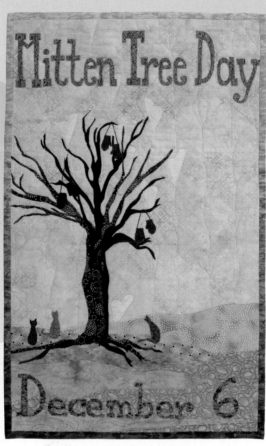

Courtesy of
Paula Golden

december 6th

December 6 has always been a special day in our family due to our European ancestry. To this day we celebrate the beginning of the winter holidays with a visit from Saint Nicholas, who arrives on December 6 with gifts of citrus fruit, chocolate, and / or onions, bundle of twigs to represent switches or if you had a *challenging* year, listening to your parents, that is, coal. Yes, I was the recipient of a lump of coal one year.

The history of Mitten tree day seems to be a mystery; however, many think it was started by a teacher, based on the book *The Mitten* by Candace Christiansen. In the book, a lady knits mittens for needy children and hangs them on a tree. Reading with my children has always been of great importance to me. *The Mitten* by Jan Brett, with its glorious illustrations, was another favorite my children read when they were little. The nursery rhyme of the three kittens who lost their mittens led to the thought of the three cats who had graced our lives over the years.

To this day, December 6 continues to be about love and family. "*Mitten Tree Day*" tells the story of our family cats (kittens) who have lost their mittens (lives). The Mitten Tree continues to hold on to the love and memories that they created as represented by the pairs of mittens forming hearts. Tigger, Tiger Lily and Tugger are part of our family history.

During my morning walks, I was inspired by a dead tree. It would be the perfect deciduous tree to hang mitten's on. It took a while to draw mitten shape that was identifiable as a mitten as well as not too clunky. In the process of extending of cord that would hold two children's mittens together I realized that I could form an upside down heart with each mitten being half a heart. This was when the quilt came together...half hearts signifying grief and healing. The movement of the upside down hearts signifies moving toward the heavens and the Universe. The sketch of the kittens came about by accident. Each of my images was too cumbersome and lacked life. I let

my pencil start doing the drawing without guiding or belaboring the design and the final shape of the cat came into being and was used with only slight alterations for the different cats.

The quilt top was constructed by using a fusible adhesive to secure the background in place over a piece of muslin fabric cut to slightly larger than the finished piece. Thinking as though I was constructing a traditional appliqué piece, I worked from the background towards the front of the image. The mountains were to be distant so they were fused in place first. The colors of those shapes were lighter and grayer in color to show atmospheric perspective.

Quilting designs followed the printed pattern in each piece of fabric. In addition to careful selection of value and color, I also consider the print quality of each fabric as I know I will be using the pattern for a quilting design. The exception to this is the background which is quilted in free form in upside down hearts.

Blacksburg, Virginia | www.paulagolden.com

Our Lady of Guadalupe
by Beth Wiesner

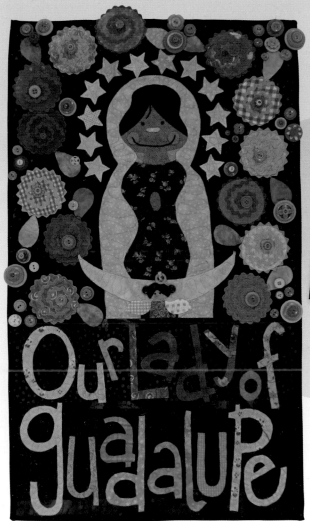

Courtesy of
Beth Wiesner

december 12th

December 12 marks The Feast Day of Our Lady of Guadalupe. In December 1531, Juan Diego heard chirping birds and beautiful music while on his way to Mass. Our Lady appeared to him, requesting that a Shrine be built in her honor on Tepeyac Hill near Mexico City. Juan Diego took her request to the Bishop of Mexico, who dismissed him. Two more times she appeared to Juan Diego, and twice more he was dismissed. The fourth time, the Bishop asked for a sign. On December 12, Juan Diego returned to Tepeyac Hill, where he found pink Castilian roses blooming in the snow. Shortly after that, the Bishop began to build the Shrine to Our Blessed Mother Mary, which still stands on the top of Mount Tepeyac.

A few years ago, I came across the religious folk art of Sister Karol Jackowski. I fell in love with her paintings of saints and knew that one day I would make a quilt in a similar style. We Catholics love our saints, and Our Lady of Guadalupe is one of my favorites for a number of reasons: everyone calls me Beth, but my first name is Mary (she is an icon of Our Blessed Mother Mary); she is the Patroness of the Americas(and I am an American); she performed "the Miracle of the Pink Roses" (I absolutely love flowers); and she appeared to an Aztec Indian in Mexico City (in my day job I am an English for Speakers of Other Languages teacher with many students from Central and South America).

My quilt is machine pieced, hand appliquéd, and machine quilted. In my world, no quilt is complete without rickrack and buttons and this quilt is no exception. Our Lady of Guadalupe is always depicted wearing a blue-green or green cloak covered with stars (on my quilt the cloak is flannel — to keep warm in the snow!). A halo of 12 stars surrounds her head. A crescent moon held by an angel lays at her feet. I tried to capture the folk art style of Sister Karol, but with a whimsy that is all my own. I hope that I've depicted some of the joy I find in my faith and in the flowers that I love with this quilt.

Woodbridge, Virginia | www.cuckooquilts.com

Poinsettia Day

by Carol E. Congdon

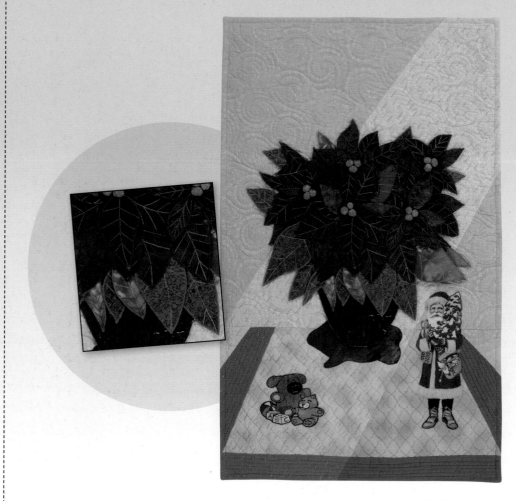

december 12th

Poinsettia Day was chosen as an opportunity to try some new techniques and ideas. This is an original design that was created as the piece progressed, there is no pattern available.

This table scape appears as though there is a light source going through the center of the room. I dyed some of the "wall paper" fabric with coffee to darken it, and bleached out some of the table cloth fabric to lighten it. I did the same with the "table" fabrics, making part of them darker than others. The background was quilted before the potted plant was attached. The sun's rays were hand-stitched with metallic thread. All seventy poinsettia leaves were done individually by machine. The pot for the flowers is Mylar, as that is what it would be if the plant were purchased at Christmas time. I did spend some time searching for this material. The teddy bears and the St. Nicholas were copied on fabric from Word Clip Art and then very slowly machine stitched, using the paper backing as a stabilizer. These pieces were a challenge, using at least 40 different threads, but they came out well (although they do look as though they were made on an embroidery machine, maybe not a plus). Now that I know how to do this, I intend to use this technique on another quilt I have been thinking about and planning for some time.

I did have one problem. The weight of the appliqués was causing some distortion to the edges, so I carefully cut pieces of twill tape to the exact 18 (width) and 30 (length) inch measurements, pinned 7 strips in each direction on the back of the top, and hand stitched them in place. This kept the piece flat and square.

Not wanting to change the coloration of the edges of the piece, and since I did not have any leftover fabric to keep changing the binding, the backing was put on using the "pillow case" method. A lengthwise seam in the center was stitched for 3 inches at top and bottom. It was then stitched all around the quilt top and the opening hand-stitched closed. Because of the dimensional construction of the pot of flowers, I could not pull the front through a small opening, and this method worked well for this particular piece.

I dyed fusible interfacing — some red, some green. I wanted some stability for them, but didn't want them stiff and didn't want to use fusible web and a second layer of fabric. I fused the dyed interfacing to the red and green fabrics and then drew leaves on the interfacing side of the fabric. I straight stitched around all the leaves on the drawn lines and the cut out as close to the lines as I could. Then I put each leaf back in the machine and satin stitched around all the edges. Once that was done, I stitched veins in each petal/leaf. Whew!

Secane, Pennsylvania

National Bake Cookies Day
by Lorraine Fenstermacher

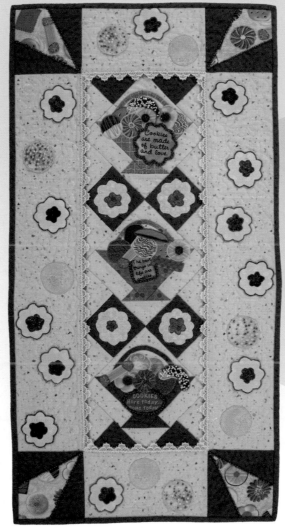

Courtesy of
Lorraine
Fenstermacher

december 18th

I have two loves: quilting and baking. When Shannon Shirley brought up her idea for this challenge at the Quilt Professional Network Conference, I thought of it as an opportunity to combine the two loves. "*Cookies in a Basket*" does just that!

I love to bake cookies and give them away to friends, the librarian, the mechanic, and U.S. military troops serving overseas.

In the beginning I made a few dozen cookies for my husband for weekend drill. Overtime when word got out he had homemade oatmeal raisin cookies, he began to bring more to each drill. At the start the cookies were small, a tablespoonful size. He asked for a bigger cookie. I switched to an ice cream scoop size cookie (about an eighth of a cup size); these were better,

but not "manly," as he put it. After some searching I found a 1/4 cup cookie scoop, and that is how the jumbo "manly" cookie came to be. All the troops in my husband's squadron asked for "manly" cookies, for 350 plus men! When he was in Bosnia, I was sending 3 boxes of cookies 2 times a month. The men would gather like flies around the boxes until they were opened. In 2008, his unit was sent to the Sinai Peninsula on the Red Sea. It was the same scenario. He is now retired, but his old unit was sent to Kuwait, and we are sending cookies to them, 3 boxes twice a month.

In 2010, I was awarded the Pennsylvania Accommodation Medal for commendable service to the Common Wealth of Pennsylvania, for my support of the Troops.

Being a traditional quilter who usually follows patterns, it was a challenge for me to design my own quilt. Combining baskets with the cookies as a way of handing the cookies out is where the idea for this quilt came from. I pieced traditional basket blocks and then filled them with a variety of appliquéd cookies. Wanting to imitate the decorations that are applied to cookies, I used beads for the chocolate chips, both dark and white, rayon thread for the icing lines, and glitter paint for the sugar cookies. The glitter in the border is a continuation of the sugar being sprinkled on the cookies.

Enjoy the cookies!

Pleasant Mount, Pennsylvania

afterword

Now that you have had a chance to look
at the 72 quilts in this book, your mind is probably
racing, I know mine is. I keep thinking about
other quilts I would like to design.

Some of you might instantly pick a day to
celebrate, while others of you will ponder all the
options for days or even months. Even if you never
make a quilt to celebrate one of the random holidays, just
thinking through the ideas and possibilities will be good
practice and exercise for designing a quilt of your own.

I would love to hear about the random holidays you
celebrate by creating quilts; whether you design one just for
the fun of it or participate in some form of a challenge. You
and a friend could challenge each other to try using a new
technique in your holiday celebration quilts. If you belong to
a small bee, you could challenge each other to celebrate the
same holiday and then enjoy all the different interpretations
and techniques used. Maybe your guild could choose
random holidays for your annual challenge. This is a
practically endless source of inspiration, so have fun
designing your own celebration quilts!

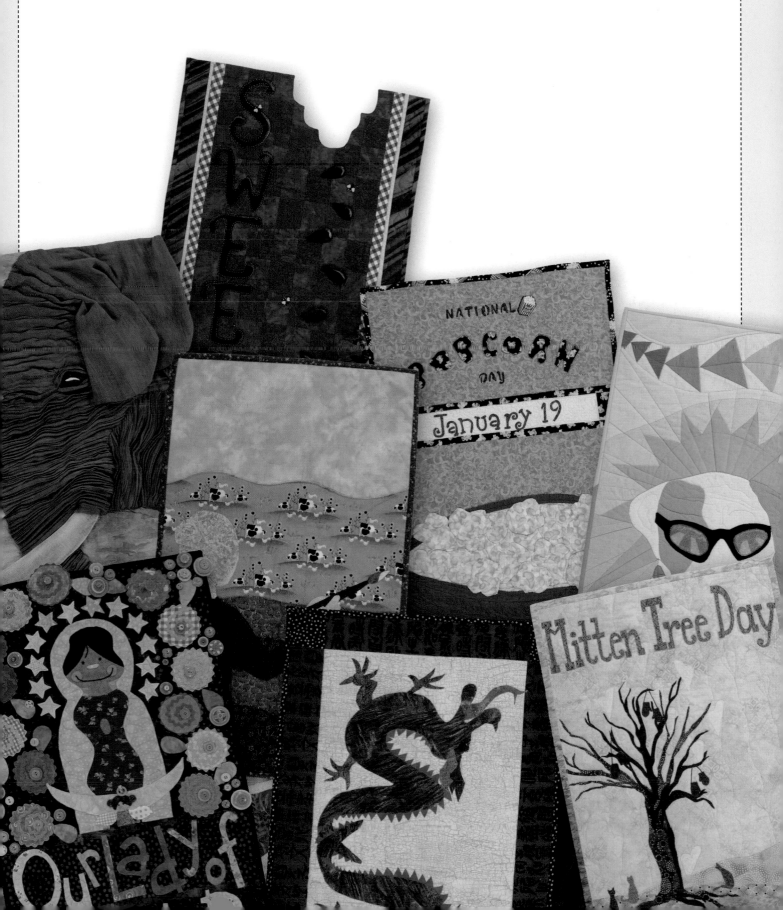

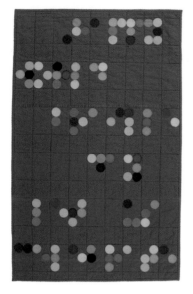

4th
World Braille Day
by Shannon Shirley

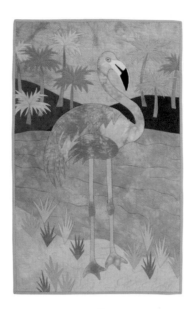

5th
National Bird Day
by B.J. Titus

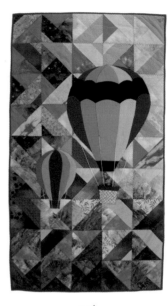

9th
Balloon Ascension Day
by Kathleen Davies

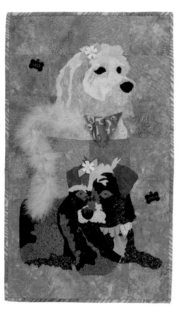

14th
Dress up Your Pet Day
by Ginny Rippe

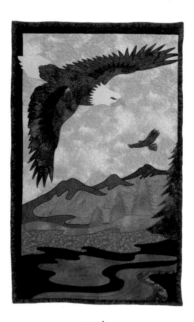

14th
Bald Eagle Day
by Cindy Sisler Simms

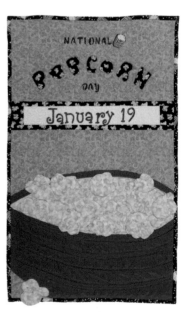

19th
National Popcorn Day
by Kathy M. McLaren

february

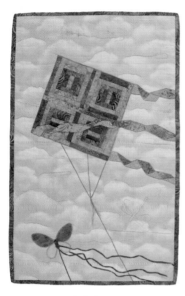

8th
Kite Flying Day
by Barbara L. Scharf

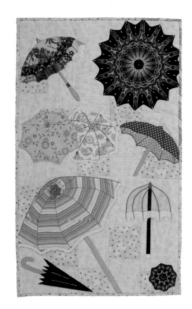

10th
Umbrella Day
by Jane W. Miller

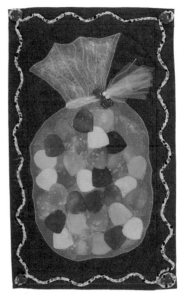

15th
National Gumdrop Day
by Pamela Baringer Shanley

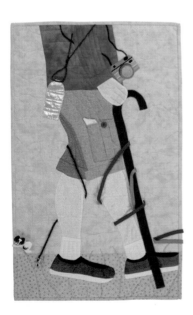

22nd
Walking the Dog Day
by Stevii Graves

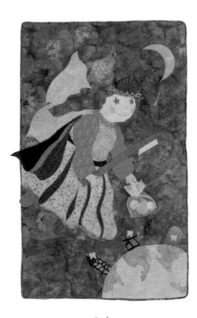

28th
National Tooth Fairy Day
by Bunnie Jordan

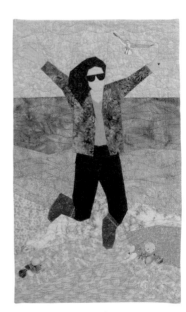

29th
Leap Day
by Shannon Shirley

5th

Multiple Personalities Day

by Erin Underwood

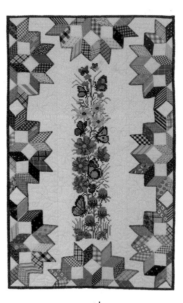

14th

Learn More About Butterflies Day

by Shannon Shirley

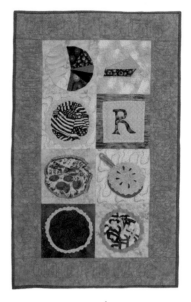

14th

Pi Day

by Marianne H. Gravely

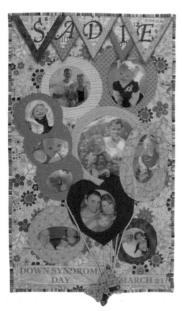

21st

World Down Syndrome Day

by Jane E. Hamilton

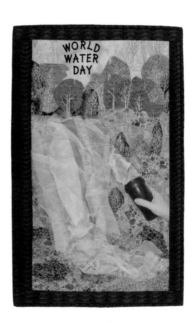

22nd

World Water Day

by Betty Jenkins

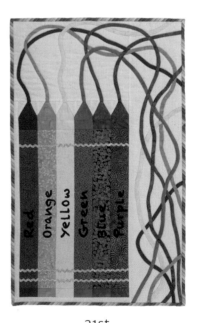

31st

Crayon Day

by Kaye McWhirter

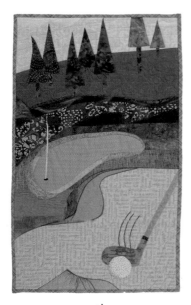

10th

Golfers Day

by Jane W. Miller

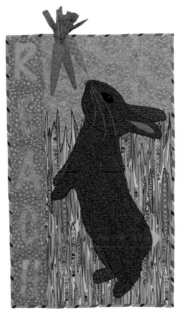

14th

**Reach as High
as You Can Day**

by Shannon Shirley

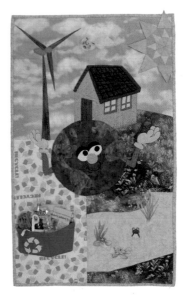

22nd

Earth Day

by Joanne Hawk

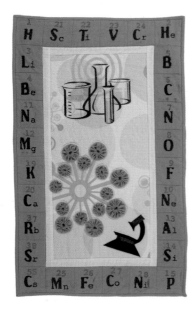

23rd

World Laboratory Day

by Beth Flores

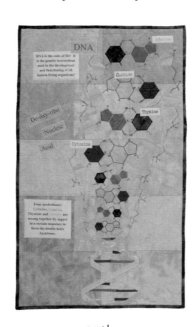

25th

DNA Day

by Renelda Peldunas-Harter

27th

Save the Frogs Day

by Carolyn Perry Goins

1st
May Day
by Beth Wiesner

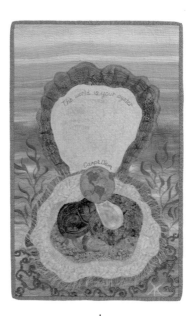

5th
Oyster Day
by Allison Avery Wilbur

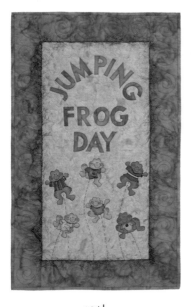

13th
Frog Jumping Day
by Mary Anne Ciccotelli

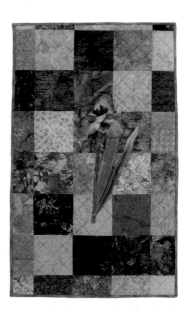

8th
Iris Day
By Kathy M. McLaren

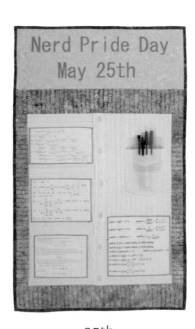

25th
Nerd Pride Day
by Kathy Lincoln

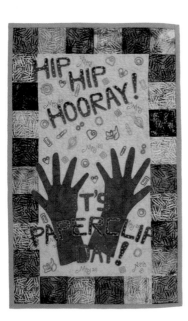

29th
Paperclip Day
by Didi Salvatierra

june

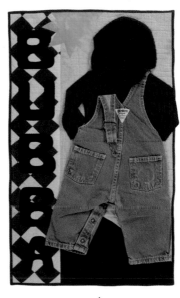

2nd
National Bubba Day
by Mary W. Kerr

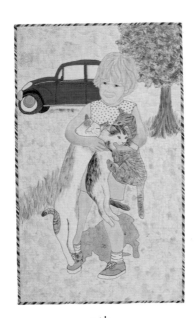

4th
**National Hug
Your Cat Day**
by Shannon Shirley

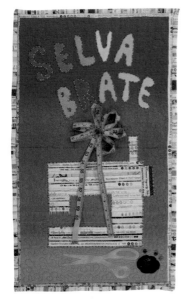

13th
Sewing Machine Day
by Ann Weaver

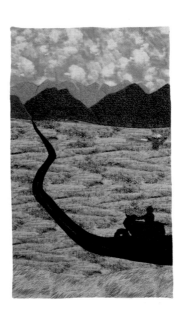

21st
World Motorcycle Day
by Meghan Hurley

26th
Beauticians Day
by Jane E. Hamilton

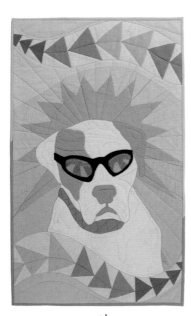

27th
Sunglasses Day
by Kathie Buckley

july

9th

National Sugar Cookie Day

by Shannon Shirley

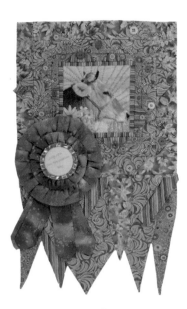

15th

Cow Appreciation Day

by Stacy Koehler

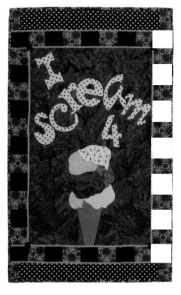

3rd Sunday

National Ice Cream Day

by Karen L. Dever

22nd

Hammock Day

by Denise Werkheiser

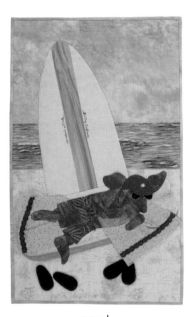

23rd

National Hot Dog Day

by Jill Sheehan

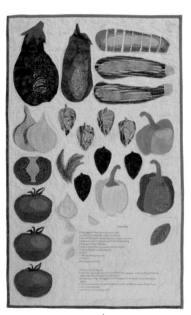

25th

Culinarians Day

by Morna McEver Golletz

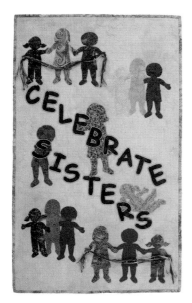

1st Sunday
Sisters Day
by Jill Sheehan

3rd
Watermelon Day
by Carlene Halsing

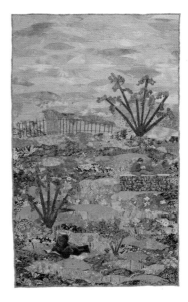

9th
Book Lovers Day
by Susan Grancio

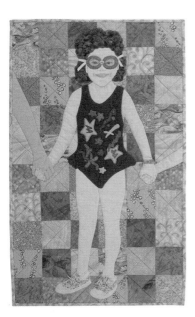

12th
Middle Child Day
by Shannon Shirley

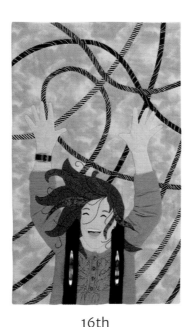

16th
National Roller Coaster Day
by Shannon Shirley

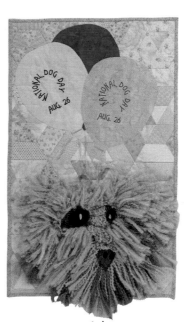

26th
National Dog Day
by Phyllis H. Manley

september

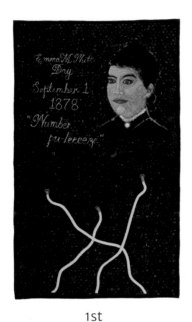

1st
Emma M. Nutt Day
by Kathy M. McLaren

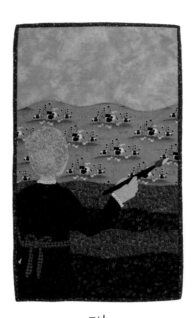

7th
Grandma Moses Day
by Donna Marcinkowski DeSoto

13th
Uncle Sam Day
by Carlene Halsing

22nd
Elephant Appreciation Day
by Lisa White Reber

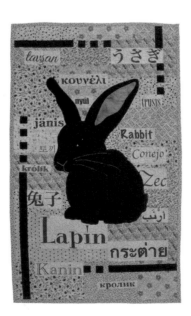

4th Saturday
International Rabbit Day
by Shannon Shirley

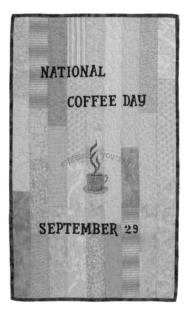

29th
National Coffee Day
by Bonnie Dwyer

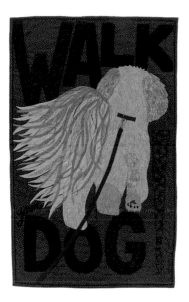

1st

**National Walk
Your Dog Day**

by Shannon Shirley

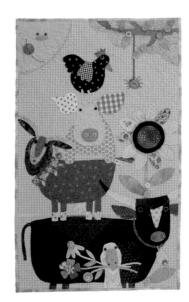

2nd

World Farm Animal Day

by Beth Wiesner

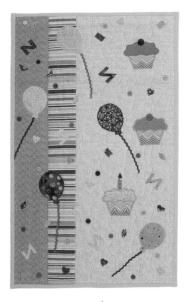

11th

It's My Party Day

by Frances Carman Berrios

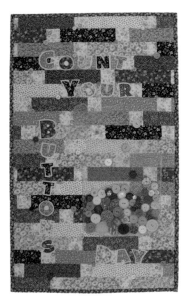

21st

Count Your Buttons Day

by June Henkel

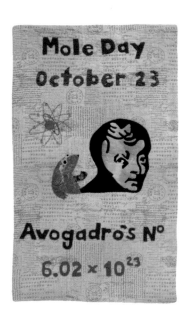

23rd

Mole Day

by Deborah Van Wyck

31st

**Increase Your
Psychic Powers Day**

by Cyndi Souder

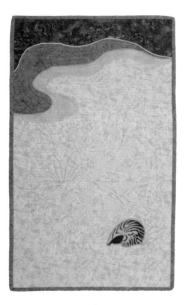

6th

**Marooned Without
a Compass**

by Vania J.Root

9th

Chaos Never Dies Day

by Pauline Davy

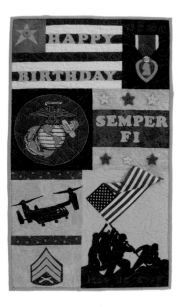

10th

Marine Corps Birthday

by Michelle Carroll

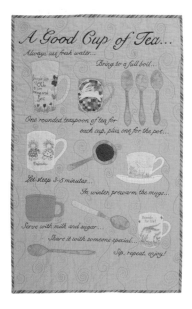

11th

Good Cup of Tea Day

by Shannon Shirley

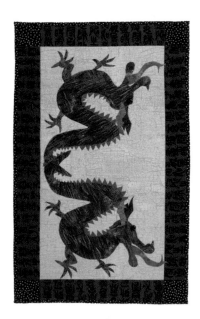

12th

National Gaming Day

by Iris Graves

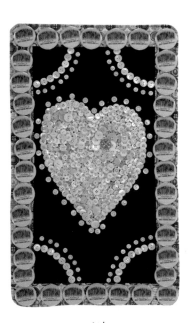

16th

Button Day

by Merry May

december

2nd
National Mutt Day
by Shannon Shirley

5th
Bathtub Party Day
by Angela Robertson

6th
Mitten Tree Day
by Paula Golden

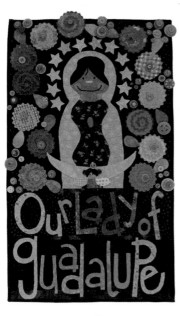

12th
Our Lady of Guadalupe
by Beth Wiesner

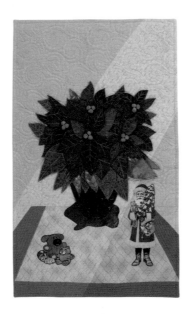

12th
Poinsettia Day
by Carol E. Congdon

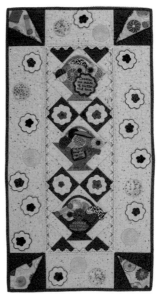

18th
National Bake Cookies Day
by Lorraine Fenstermacher

celebrate your day!

What day will you celebrate?
Sketch and design your day in the following pages, or
add photographs of quilts you make to celebrate special days!

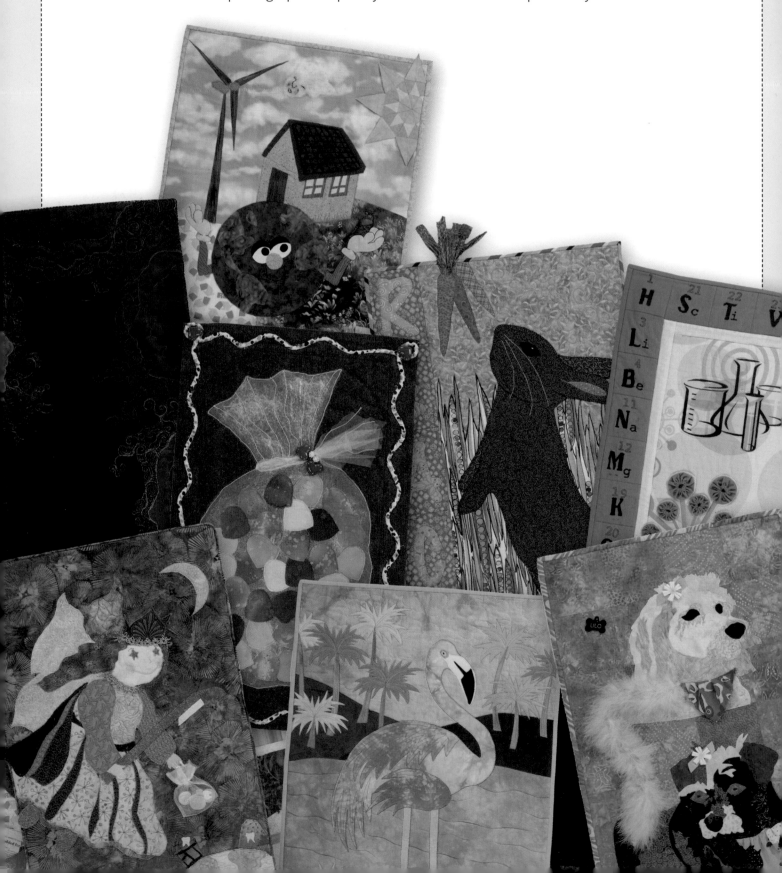

_____ _____
 month day

 holiday

_____ _____
 month day

 holiday

_____ _____
month day

holiday

_____ _____
month day

holiday

_____ _____
month day

holiday

index

about the author

Shannon is an artist, teacher, speaker, author, and an award winning quilter. She grew up in an Air Force family and moved throughout her childhood. She fondly remembers hand sewing classes at the village school she attended in England. She has lived in Northern Virginia since 1974. After high school she received an Associates degree from The Fashion Institute of Technology in New York City. For a number of years, she worked in the merchandising and display fields for Woodward and Lothrop in Virginia. Shannon has three grown daughters who are all creative in their own right. Art in just about any form has always inspired her. In most areas of her life she has eclectic taste, and likes change and variety, so it seems only natural that her quilting is eclectic as well. She uses a wide variety of techniques and materials—whatever seems to suit the project at hand. Her parents gave her a Bernina 1130 in 1989 and it is still her machine of choice. Shannon enjoys both traditional quilting and art quilting. She prefers to design original quilts, working from the stash she has collected over the years. Letting the projects evolve as she works, one common thread in her art would be mixing a large variety of printed fabrics.

Shannon has enjoyed creating original stain glass pieces and painting ceramics. She would love to learn to knit and crochet. There just isn't enough time in the day to create all the ideas that are in her head, or enough room to store all the supplies she would love to own. So, her mediums of choice are fabric and thread.

Shannon has been teaching professionally since 2006 and loves working with students of all ability levels. She particularly enjoys when she is able to help someone overcome a stumbling block of some kind. She looks forward to hearing from her past students and seeing their quilt projects, and would like to see what you are inspired to create after reading *Celebrate the Day with Quilts.*

Shannon can be reached via email at: onceinarabbitmoon@comcast.net
You can see more of her work at: www.onceinarabbitmoon.com